LEARNING
FROM
THE EXPERTS

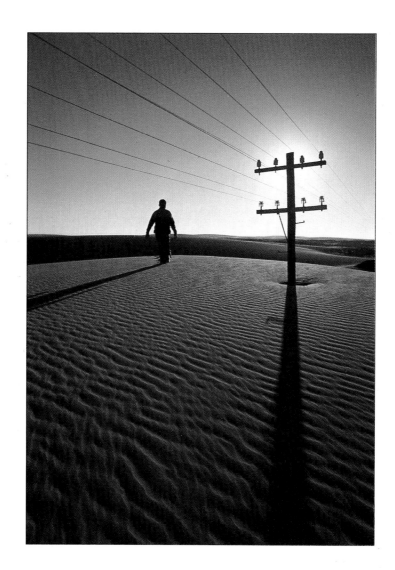

LEARNING
FROM
THE EXPERTS

Published by Time-Life Books in association with Kodak

TIME
LIFE
BOOKS

LEARNING FROM THE EXPERTS

Created and designed by Mitchell Beazley International
in association with Kodak and TIME-LIFE BOOKS

Editor-in-Chief
Jack Tresidder

Series Editor
Robert Saxton

Art Editors
Mel Petersen
Mike Brown

Editors
Louise Earwaker
Richard Platt
Carolyn Ryden

Designers
Marnie Searchwell
Stewart Moore

Picture Researchers
Veneta Bullen
Jackum Brown

Editorial Assistant
Margaret Little

Production
Peter Phillips
Androulla Pavlou

Coordinating Editors for Kodak
Paul Mulroney
Ken Oberg
Jackie Salitan

Consulting Editor for Time-Life Books
Thomas Dickey

Published in the United States
and Canada by TIME-LIFE BOOKS

President
Reginald K. Brack Jr.

Editor
George Constable

The KODAK Library of Creative Photography
© Kodak Limited. All rights reserved

Learning from the Experts
© Kodak Limited, Mitchell Beazley Publishers,
Salvat Editores, S.A., 1985

Library of Congress catalog card number 83-51660
ISBN 0-86706-240-1
LSB 73 20L 14
ISBN 0-86706-239-8 (retail)

Contents

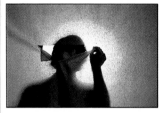
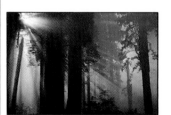

THE CONFIDENT EYE

Absolute consistency of results — producing a desired picture with every click of the shutter — is not necessarily an ingredient of photographic expertise. Even top professionals make mistakes. But one characteristic that sets the expert apart from most amateurs is an unerring sureness of intention. The best photographers are fully aware of the effect they want to achieve, of the compositional and technical means for achieving it, and even of the uncontrollable variables that might, at worst, sabotage the appearance of the picture.

The images on the following nine pages, all by photographers who have won international acclaim, show a wide range of contrasting intentions. For example, the picture by Burt Glinn opposite catches a moment of dramatic action, conveying a sense of speed, urgency and narrative. Other pictures in this portfolio are concerned with human character or the environment we live in, or take an idiosyncratic approach that reflects the photographer's esthetic preoccupations. However, the link between all the pictures here, and in the rest of the book, is that they attain excellence within limits that the photographers have set themselves. This clarity of purpose is one of the fundamental lessons that amateurs can learn from professionals. In part it depends on a thorough mastery of technique. Once you are familiar with the repertoire of techniques available, you can go on to confidently photograph any aspect of the world that interests you and, in the process, develop your own individual style.

Speeding toward the camera, a car splashes through shallow water, its headlights piercing the gloom. Glinn had a precise image in mind and went to great lengths to capture it, using a telephoto lens on a remote-control camera: the "puddle" is a water trough on the test track of General Motors in Detroit. But although carefully set up, the picture has a marvelous freshness, as if it were a lucky glimpse of a moment of action.

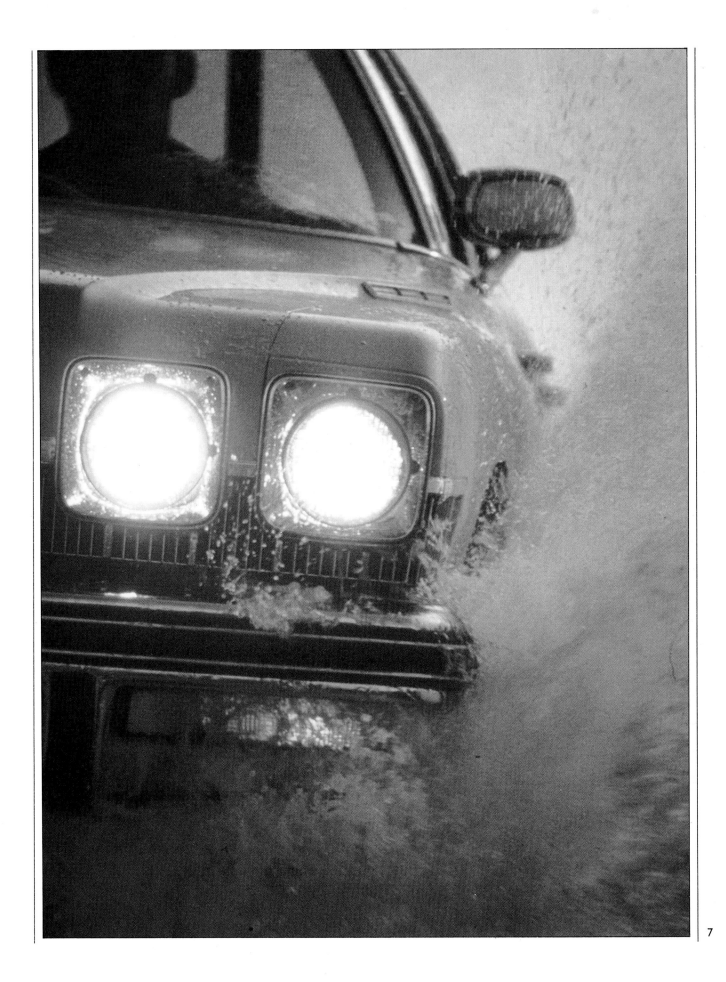

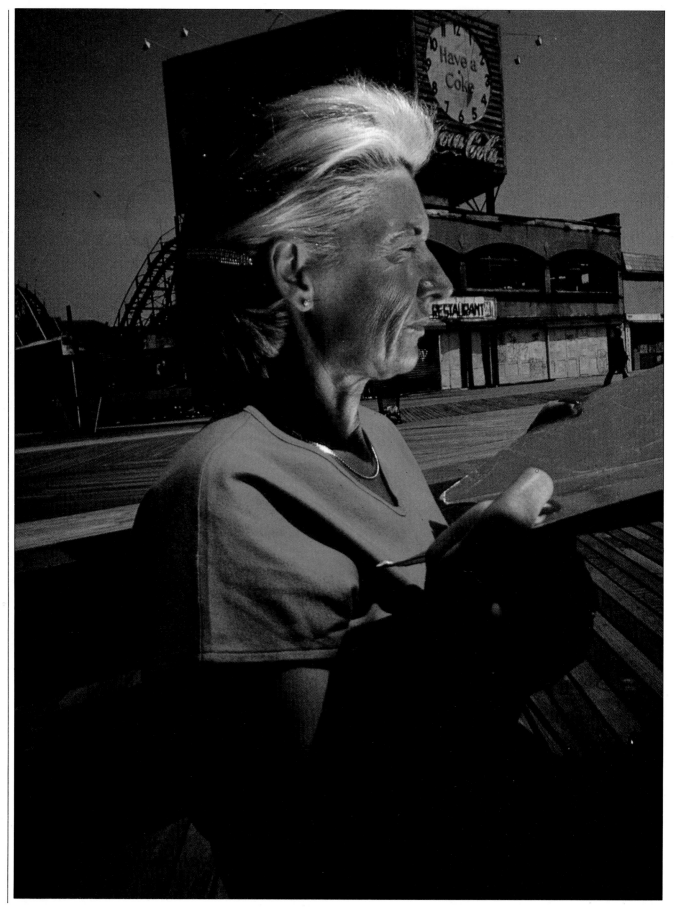

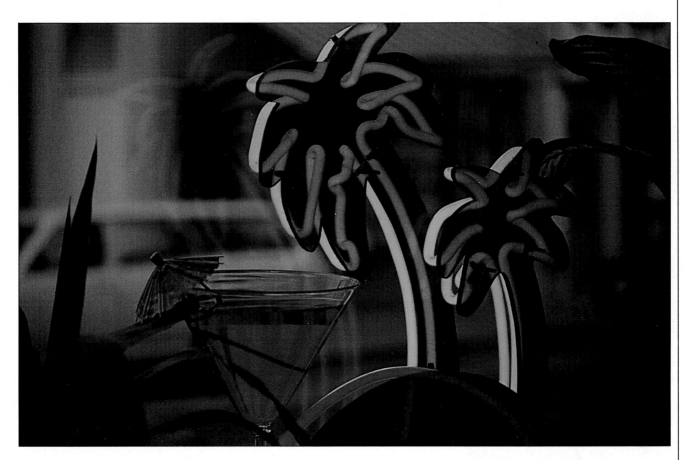

A profile of a silver-haired woman (left), dramatically lit by a sun reflector, stands out sharply against a Coney Island boardwalk setting. Photographer Burk Uzzle used a 28 mm wide-angle lens to give the view its extraordinary sense of depth. Because the woman had closed her eyes, he was able to take a perfectly candid picture.

Red liquid in a glass and a pair of neon palm trees form the window display of a cocktail bar. Photographing the display from inside, Michelle Garrett emphasized the brilliant hues by setting them against the gray street scene beyond the window. She included the curving leaves of a plant in the frame to balance the composition.

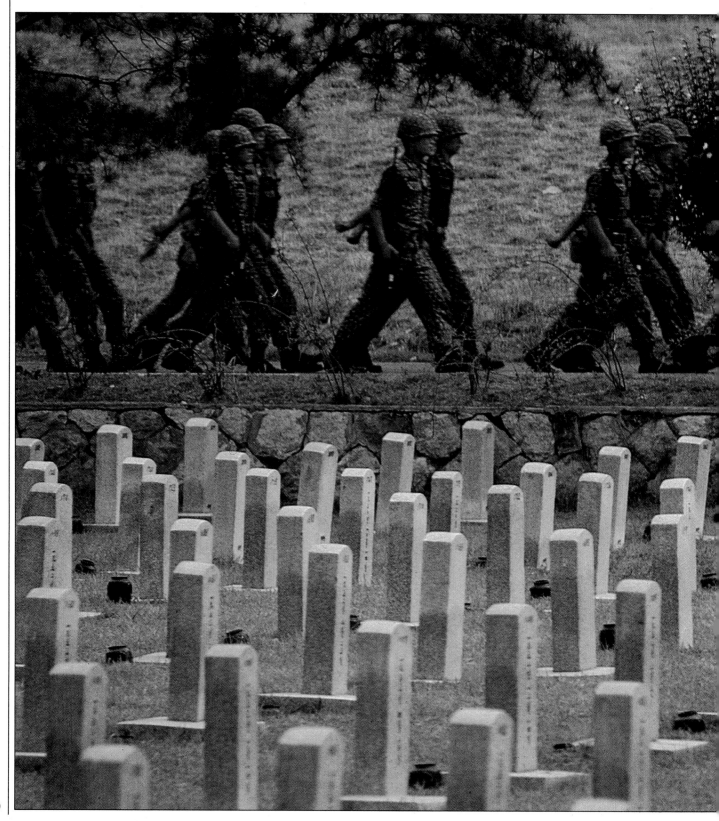

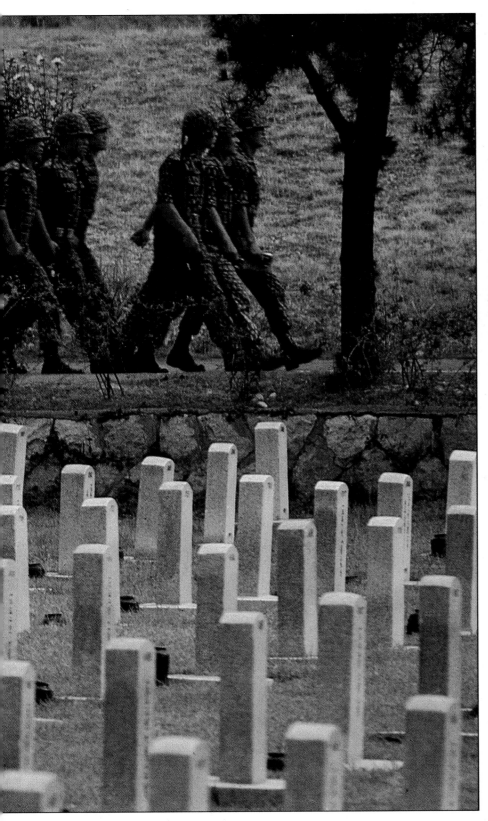

A platoon of soldiers (left) marches in step past the Seoul National Cemetery in South Korea. By dividing the composition into two distinct halves – the living and the dead – photographer Philip Jones Griffiths created a powerful image with unmistakable connotations of warfare's mass destruction.

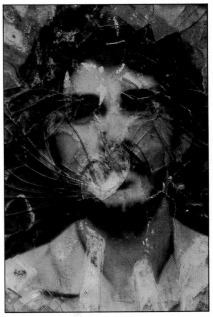

A portrait (above) behind its shattered glass cover makes a moving statement about loss and grief. Photojournalist Chris Steele-Perkins found this damaged memorial photograph of a young Palestinian in a bombed cemetery near Beirut in 1982. Cropping in closely on the picture produced a more intensely personal image than a more extensive view of the war damage could have achieved.

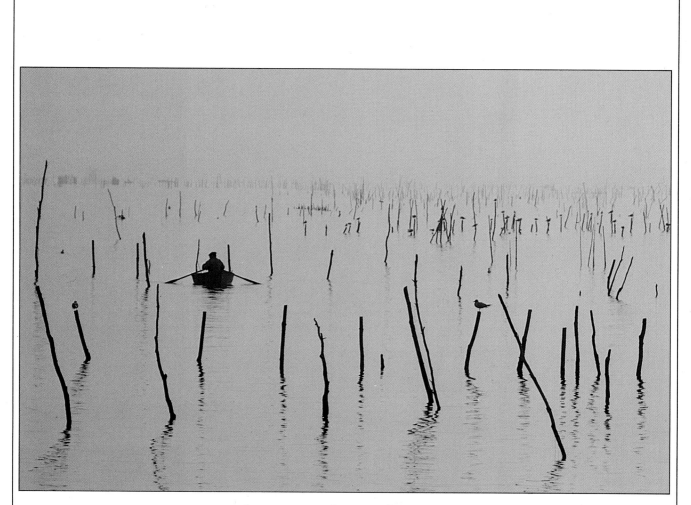

A one-man rowboat negotiates
oyster beds in Guyenne, France, in a
moody picture by Adam Woolfitt. The
misty morning light accentuated the
monochromatic quality of the scene.
Woolfitt deliberately overexposed by
one stop to bleach out detail from the
sky and the lake and to intensify the
picture's ethereal delicacy.

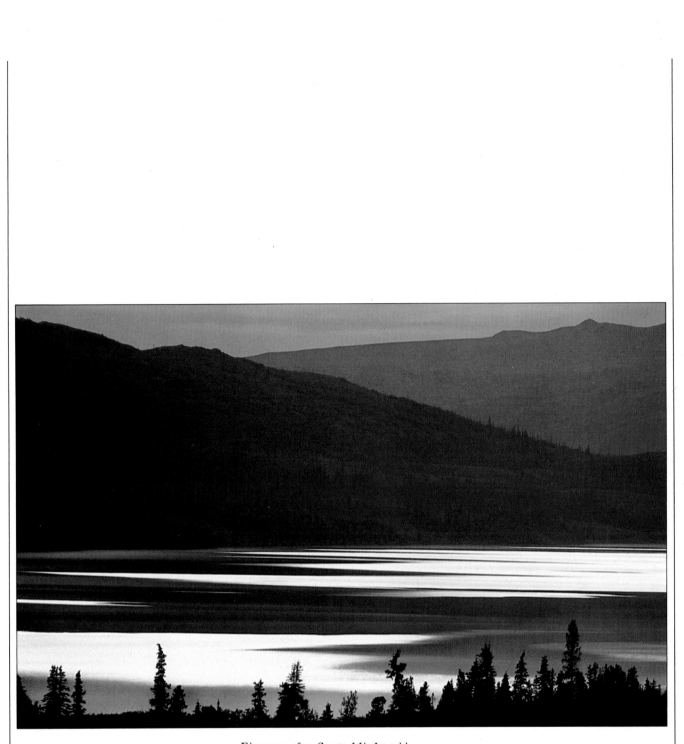

Fingers of reflected light add compositional interest to a view of Wonder Lake, Alaska, taken with a 200mm telephoto lens by landscape photographer Harald Sund. The high contrast in the scene made exposure critical, so Sund bracketed to be sure of a good result. The conifer tops in the foreground establish depth.

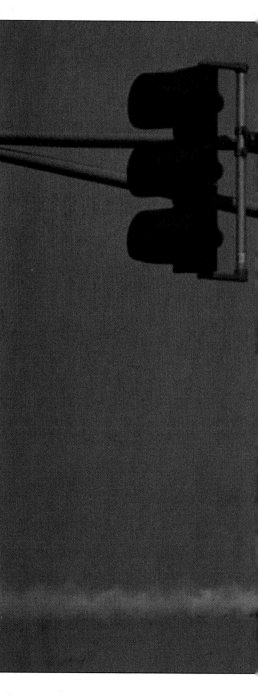

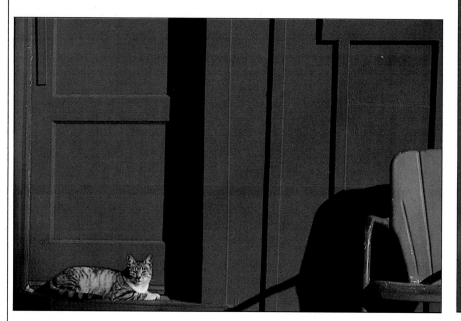

A cat on a doorstep gazing sleepily
at the viewer animates a semi-abstract
composition by Arline de Nanxe. *Careful
framing of the scene excluded any colors
that would have disturbed the harmony of
the photograph. And by placing the cat
in the bottom corner of the picture, the
photographer emphasized the sense of
contented repose.*

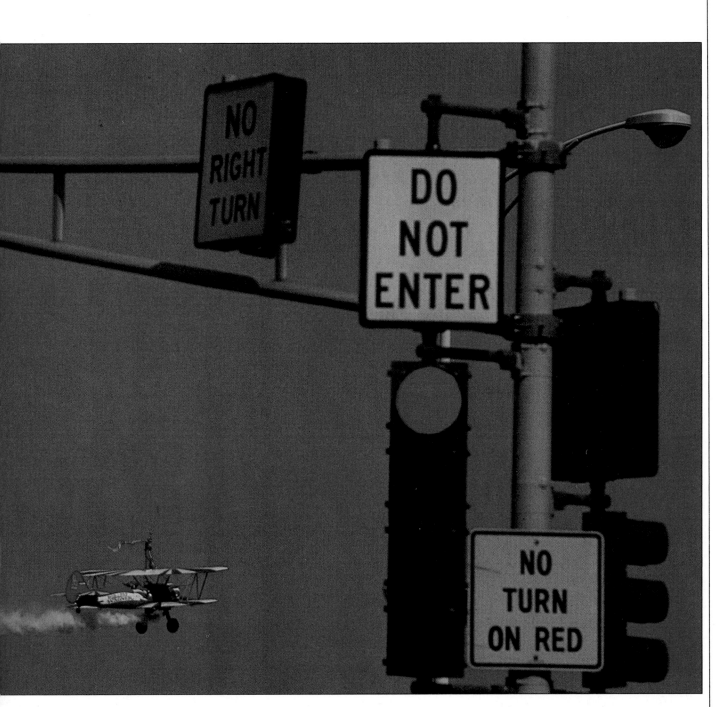

Road signs and stoplights frame a
view of a low-flying biplane, taken by
René Burri with a 135 mm lens. Burri
waited until the light was red, to echo
the red paintwork of the plane. The
smoke trail gave a powerful impression
of movement, creating an implicit contrast
with the forceful message of the signs
and the stoplight.

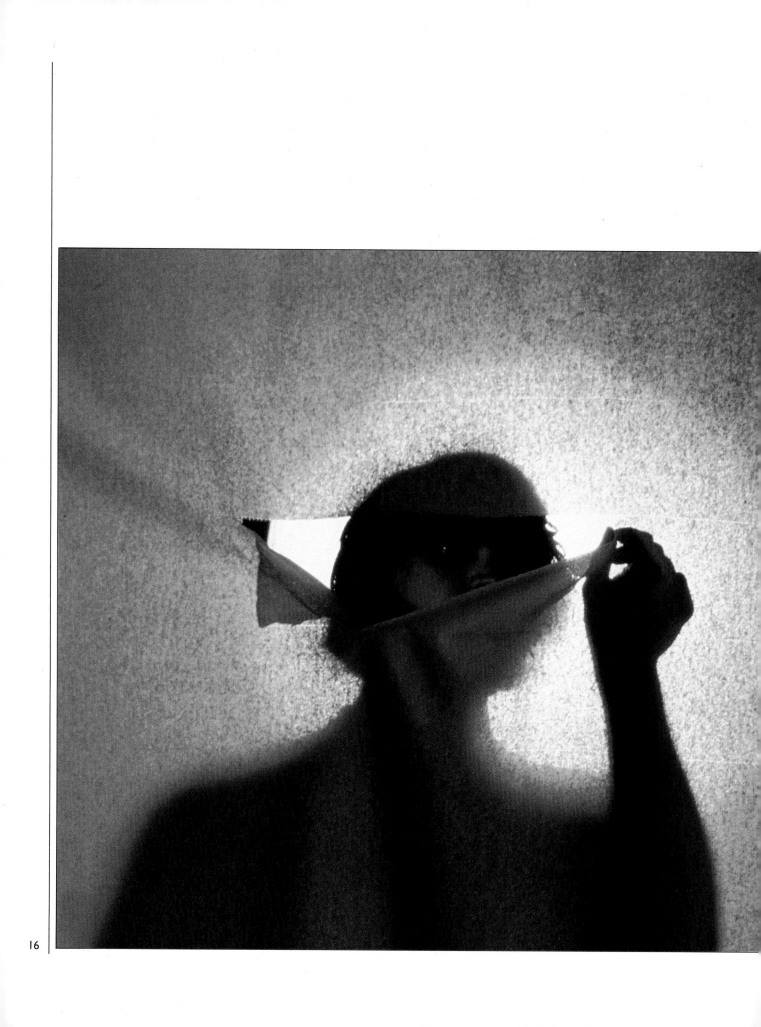

PEOPLE OBSERVED

To reveal character, the aura of personality that can shine through a person's features, is a motive that has inspired many great pictures by the world's top photographers. Another concern, equally valid, is to show people in a context that gives us information about some aspect of their lives – their work, their home environment, their leisure activities and so on. Yet another strategy taken by many photographers is to create images that are more oblique and somewhat teasing; for example, the picture opposite tells us nothing about either character or context, yet it is partly this very reticence that makes it such a beautiful image.

In the following section, the photographers represented all bring an individual vision and a wide range of techniques to their observations of people. Many of the pictures shown carry a powerful atmospheric or emotional charge. Others are memorable for reasons of technique – perhaps because of a radically original treatment of light, composition or viewpoint, or a mixture of all three. The images range widely in place, time and intention. But all of them display aspects of expertise and imagination that offer many lessons to the amateur.

A rip in a sheet of paper frames the face of the mill worker whose task it is to monitor quality. By backlighting the scene, and closing in on the resulting silhouette, photographer Paul Fusco cut out the factory clutter that often mars such environmental portraits, and made a powerful, mysterious image.

Daily life /1

In one orthodox approach to candid photography, the photographer tries to make himself invisible to the subject by using a long-focus lens from a distance. This was how Robin Laurance captured the reclining man's expression in the center picture here. But some photographers prefer the more intimate relationship that a 50mm lens brings. As the pictures by Laurie Lewis below and opposite show, this strategy can yield images in which the subjects seem oblivious of the photographer, but actually have simply become accustomed to his presence.

Although taking two contrasting approaches, these studies of British life have two important qualities in common. One is a compositional artfulness that their snapshot feeling belies: notice, for example, how the horse's head and neck in the center picture are echoed by the shipyard gantries behind. The other quality they share is a gently humorous sympathy for their subjects. Each picture is the result of patient observation, and belongs to a sequence of similar views reflecting an intense fascination with the movements of ordinary city folk.

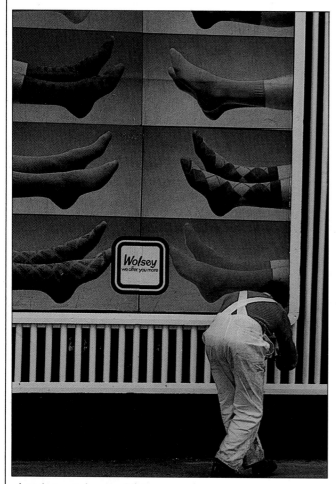

A painter (above) adds the finishing touches to a south London billboard that bears a massive advertisement for socks. The photographer saw comic incongruity in the pairs of disembodied feet pointing toward each other. The white-painted frame, the white overalls and the square white label on the poster unify the composition.

A tattooed tinker in Newcastle's docks squints at his carthorse while enjoying a smoke. The photographer, Robin Laurance, stood many yards away and used a 135mm lens which threw the dockland machinery in the background slightly out of focus, thus organizing the composition into two distinct planes.

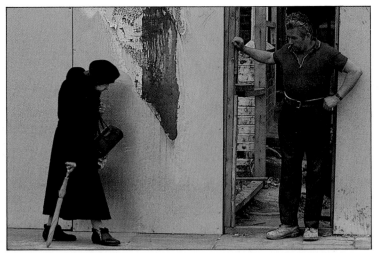

A laborer (*left*) *pauses to examine a woman out shopping. Fascinated by her hunched black shape, Laurie Lewis took a dozen pictures of her as she walked down the street, but she ignored him completely. For this view, he stood opposite an interesting rust patch on a wall and waited for her to catch up with him.*

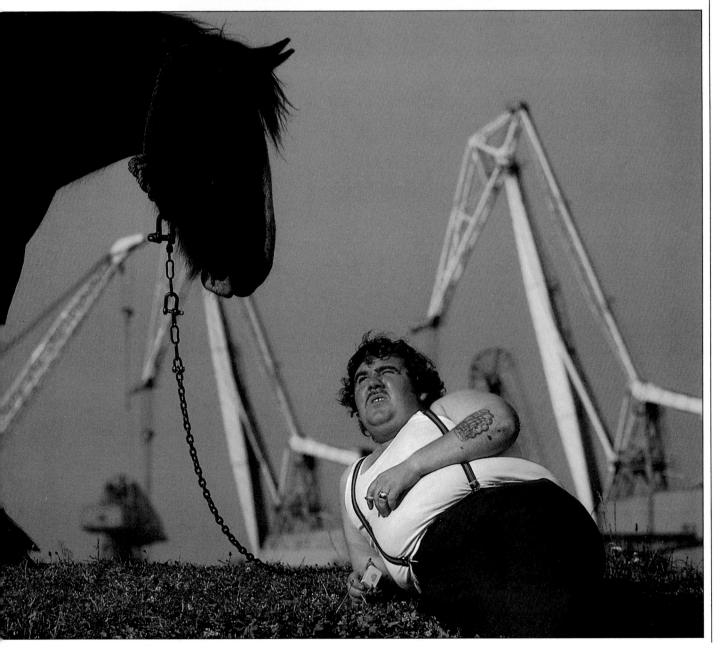

Daily life /2

Street life is one of the most varied and accessible of all subjects for the camera. Even in a modest photo-essay you can present a relatively detailed portrait of modern design, dress, transportation, work and recreation.

Although there are potentially good photographs on every sidewalk, the choice of camera angle, lens and lighting in most situations is critical. Two photographers who excel at using viewpoint and light to organize urban chaos are Mireille Vautier and Arline de Nanxe, who have a partnership based in Paris. The pictures on these pages, all taken on one trip, illustrate their consummate skill. Their commission was to take photographs for a book on California, with an emphasis on Los Angeles. Using a wide range of lenses, they wandered through the city, watching for the right light on a face or a building; and on the way they stopped at Las Vegas to take pictures for a magazine story.

One indication of the flexibility of this photographic partnership is the variety of approaches to background in these images. The setting dominates overwhelmingly in the Las Vegas view opposite, making midgets of the human subjects. By contrast, in the center picture here, the background adds offbeat interest without distracting attention from the tramp. Another approach is taken in the picture below at left: the massive red spiral of the sculpture is a highly photogenic monument, yet here it is used discreetly to unify a portrait of two businessmen. Simplification of background is taken still further in the picture on the opposite page at far right.

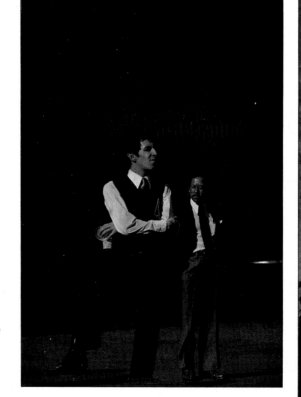

Two men, observed from afar with a zoom lens, wait for a taxi on a Los Angeles sidewalk. On a sunny day, any street will have parts that are deep in shadow and this can pose a problem for photographers. But here Mireille Vautier used shadow to simplify the composition. The spiral sculpture behind the men adds elements of rich color and elegant form.

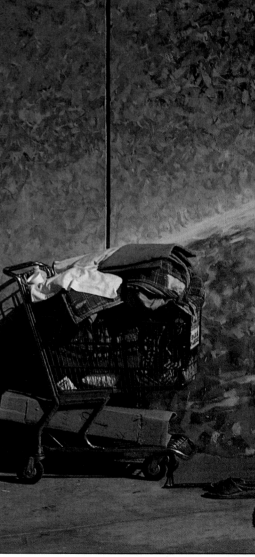

An outdoor mural (right) in Venice, Los Angeles, makes an incongruously colorful background for a view of a tramp and his shopping cart of blankets. Using a 21mm lens from just a few feet away, the photographer could not avoid waking the man, and caught his surprisingly benign expression as he peered at her.

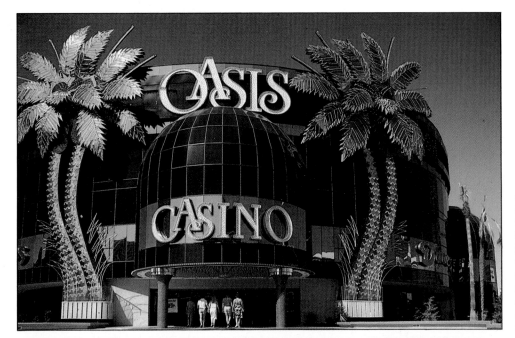

A Las Vegas casino forms an elaborate frame for five tourists walking together toward the entrance. Most photographers prefer Vegas at night, when it throbs with neon; but here an unusual daytime view, taken with a 28 mm perspective control lens, captures one of its architectural fantasies.

A sidelong glance in a shaft of light (above) makes an expressive portrait. Intrigued by the red lips, the cascade of hair and the sullenly beautiful face, the photographer took several candid pictures of this shopper, using a zoom lens from a hidden viewpoint among the shadows.

The telling moment

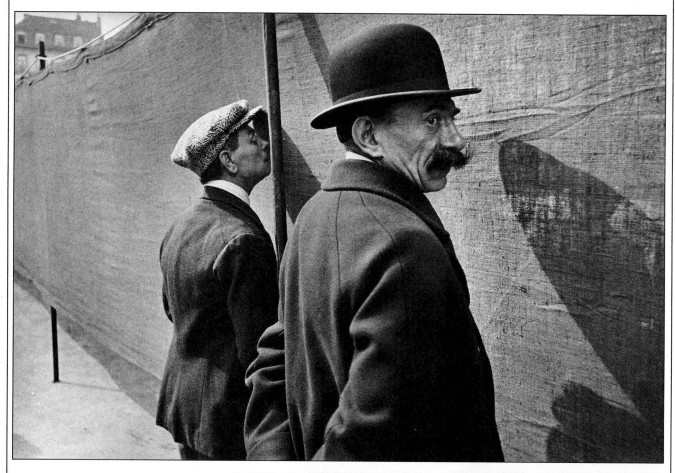

Human curiosity (above) *involves the viewer, too, in this candid study of two snoopers: we long to know what is going on behind the screen. Tension is provided by the contrasting attitudes of the men: one is glued unashamedly to his peephole, the other looks away furtively, as if his respectability is being compromised.*

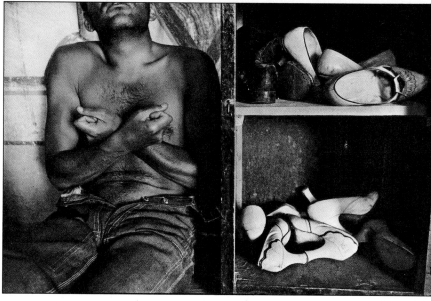

A surreal juxtaposition (right) *is emphasized by viewpoint and tight framing. The bold vertical division of the image keeps the eye moving from one compartment to the other, yet the visual link between the shapes of the crossed hands and the shoes unifies the picture.*

The ability to draw surprise and drama from the most mundane situations is a hallmark of the French master Henri Cartier-Bresson. All his photographs have a strong human-interest appeal, and whether or not the subjects are aware of the camera, the impression is always absolutely candid.

Cartier-Bresson is most often associated with the decisive moment of picture-taking: an unrepeatable instant in time when a dynamic gesture, expression or action is frozen in equilibrium by the camera's shutter. However, the exactness of his framing and viewpoint are just as critical as his timing. Cartier-Bresson's pictures are always printed full-frame, never cropped. One key to his instinct for composition is total familiarity with his equipment: he has taken many of his photographs with the same Leica rangefinder camera (quieter and more compact than an SLR), kept hidden under his coat until needed.

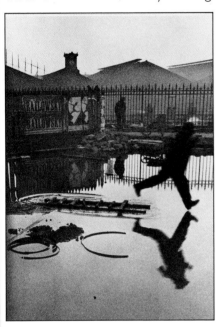

A shadowy figure (above) is frozen by the camera in the act of jumping over a puddle: The subject's movement toward the edge of the frame, repeated strongly in the reflection, creates an image of dramatic suspense from an everyday event. Taking the picture a second earlier or later would have given quite a different meaning to the scene.

The occupant of a cell (right) in a New Jersey prison thrusts an arm and a leg through the bars to express frustration. The sudden, violent gesture is accentuated by the angle of view; the rigid geometric lines of the setting are contrasted with the dynamic human form.

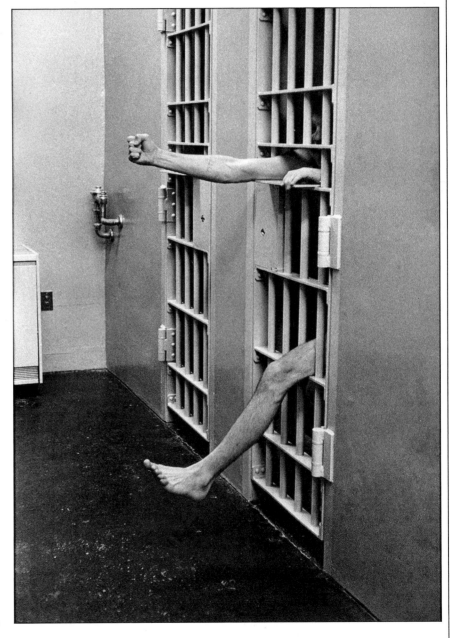

Captive subjects

An enclosed community offers the photographer superb opportunities to study people at close quarters over a period of time. Life aboard ship is a classic example; for the duration of the voyage, the ship is a kind of floating studio, with both natural and artificial lighting. The rewards to be derived from such a self-contained environment are exemplified in the pictures shown here, taken by Kenneth Griffiths on a cruise aboard the QEII.

Griffiths' subjects are captive but willing. He usually works with a large wooden view camera, which rules out the unobtrusive approach. Instead, he sets out deliberately to involve people as he plans a picture, using instant prints not only to test composition and focus but also to reward cooperation. Many of his pictures have a candid feel, as in the view below, but all are taken with the subjects' full knowledge.

One of the themes of these pictures is the ordered structure of life on board, with its many little rituals: taking a walk around the deck, stretching out on deck chairs to sunbathe, and so on. The passengers' determination to follow such routines whatever the weather is a source of affectionate humor. But there is also something sharper: an unexpectedness — for example, in the framing of the picture at the top of the opposite page — that gives some of these images a highly individual stamp of the surreal.

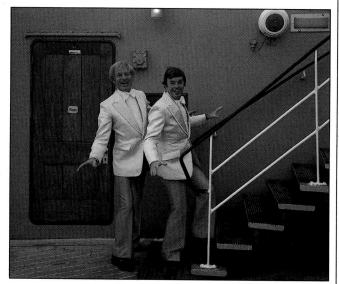

Ship's entertainers (above) *in brocade jackets ham it up. To convey their extroverted personalities, Griffiths encouraged the duo to play to the camera. Their pose suggests the slick delivery of a well-rehearsed song and dance act.*

A shadowy figure (below) *is glimpsed through misted glass as she takes a bracing walk. The leaden sky, the gray sea and the chairs stacked on the wet, deserted deck all contribute to a wintry atmosphere seldom associated with cruises.*

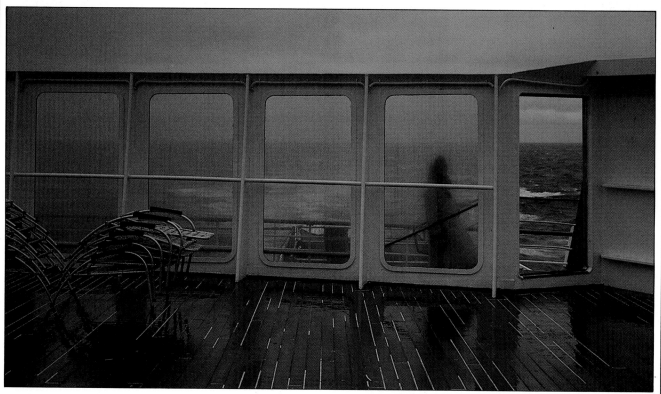

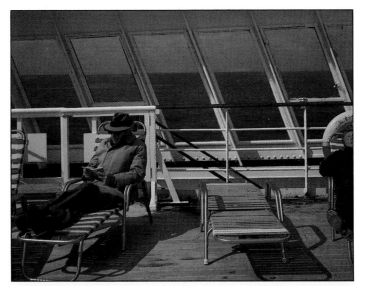

Two men in deck chairs, well wrapped up against the wind, enjoy weak sunshine. The photograph gains in compositional impact from the pattern of crisscrossing lines and the novel framing that crops the right-hand figure and the life ring.

Pairs of legs (below) resting on a deck rail evoke comfortable companionship. The unusual viewpoint creates strong diagonals that, with the blur of foam, convey rapid movement, in contrast to the relaxed pose of the vacationers.

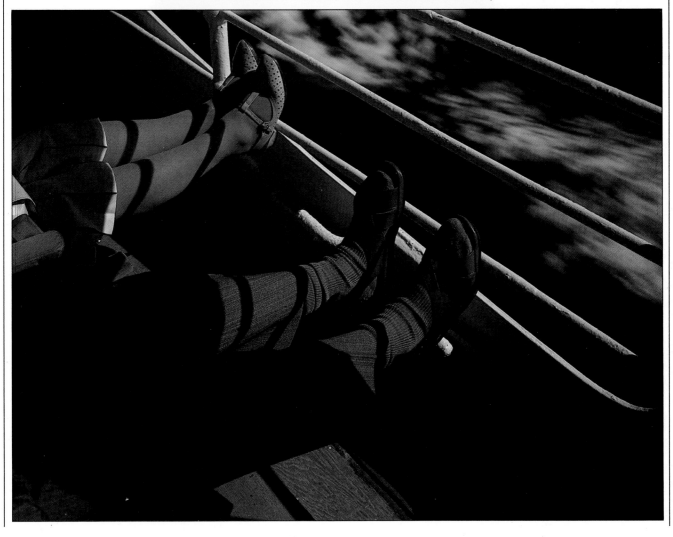

Relationships

People who are involved with one another tend to reveal a great deal more of their personalities to the camera than when they are photographed alone. If they are aware of the photographer's presence, the knowledge that a companion is sharing the attention is likely to make them more relaxed and natural. And if they are unaware of the camera, the give-and-take of a conversation makes candid pictures livelier and more expressive: a person alone or among strangers is apt to maintain a private demeanor.

Jane Bown, who took these pictures, has photographed both unknown and famous faces for a British national newspaper for more than 30 years. Newspaper photographs all too often lose their rele-

vance as quickly as last week's news. But Bown's imagination, skill and intuitive understanding of her subjects enable her to make images that transcend time. The center picture here and the one on the opposite page at far right both record particular political events. Yet they retain their freshness and impact because they are principally studies of human nature, just as the other two pictures are.

The photographer's gentle, unobtrusive approach allows her to come close to her subjects and draw them out. As a result, in each of these pictures we can sense a strong bond between the subjects — whether of kinship and culture, age and environment, or the intense, if brief, tie of politics.

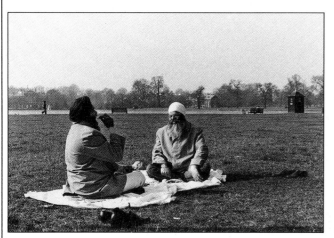

Two Sikhs (above) *chat in London's Hyde Park. The shoes on the grass, the traditional turbans and long beards, and the cross-legged poses distinctively separate the pair from their English context. Yet because of the Sikhs' companionship, it is the background figures who seem isolated.*

British Foreign Secretary David Owen talks with US Secretary of State Cyrus Vance at a summit conference (right). Body language — the urgent thrusting forward of the speaker, the cool balance of the listener reserving judgment — is so perfectly caught that we almost feel present at the debate.

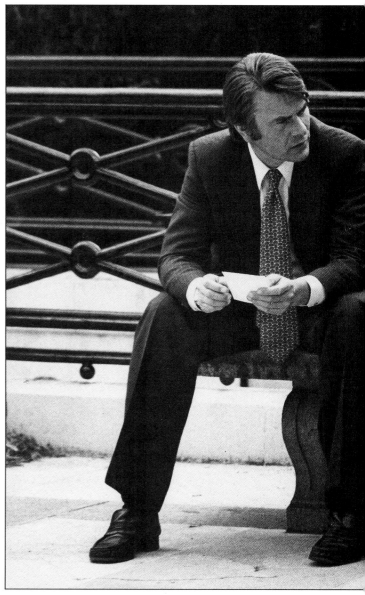

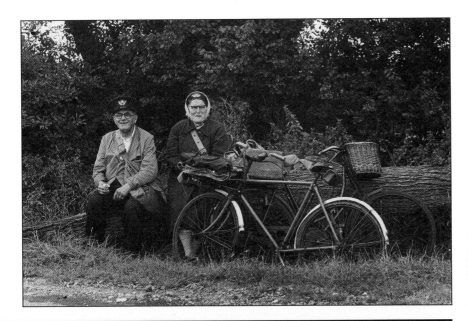

A postman and postwoman (left) *break their delivery round to enjoy a picnic in a leafy lane. The stalwart pair with their mailbags and bicycles evoke the mood of English rural life as strongly as any picturesque landscape.*

Hugh Gaitskell and Aneurin Bevan (below), *two leading figures in British postwar politics, walk the promenade at Brighton during the 1957 Labour Party conference. Rather than a conventional picture of well-known faces, Bown chose this candid rear view, which gave the subjects an air of vulnerability.*

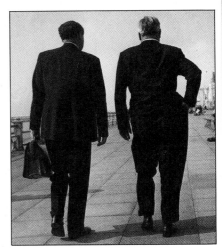

Living history

Most societies have remnants of their past scattered among the evidence of their present way of life. Continuities and contrasts between past and present can make telling images. However, achieving this kind of symbolic imagery requires patience and, above all, curiosity – a willingness to absorb yourself in all aspects of a society's social, economic and political circumstances, so that you will be able to recognize eloquent compositions whenever they present themselves.

Moroccan-born Bruno Barbey, whose moving images of Poland shown here were first published in *Life* magazine, takes a painstakingly documentary approach to his photography. He made four trips to Poland, one of them lasting a whole year, and drove many thousands of miles in a camper. Together with a mass of preparatory research, these travels gave him a remarkable understanding of the country. The

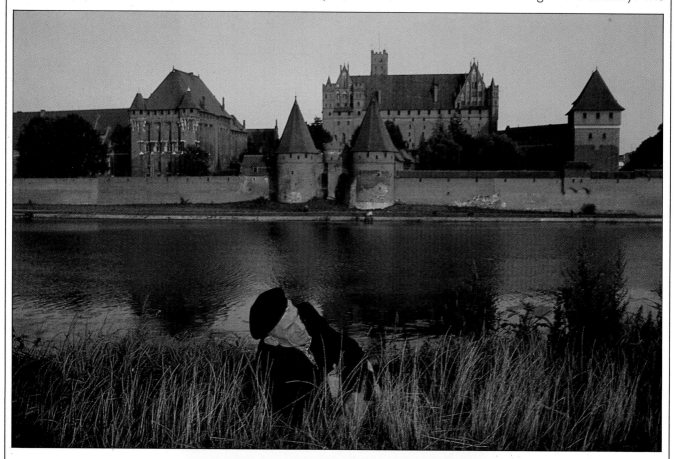

The castle of Malbork (above), south east of Gdansk, catches the late-afternoon sun, its medieval splendor contrasting evocatively with the peasant lying on the opposite riverbank. A 35mm lens recorded these distant elements of past and present on one frame to create a memorable image.

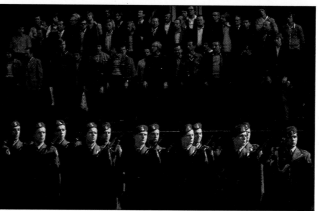

Polish soldiers (left), their faces highlighted by bright sunlight, present arms at a parade in Cracow in May, 1981. Closing in with a 135mm lens, Barbey chose a composition that placed the soldiers and the civilian onlookers in opposite halves of the frame, subtly implying conflict of interests.

fruit of his labors was a monumental photo-essay evoking all the strands of the Polish experience: the deep-rooted attachment to the Catholic Church, the tragic history of Nazi occupation, the peasant communities of the countryside, the workers' struggle for political rights, the formidable presence of a military machine. Barbey's pictures, boldly composed with hard-hitting contrasts, communicate strong sympathy for the people of a foreign nation.

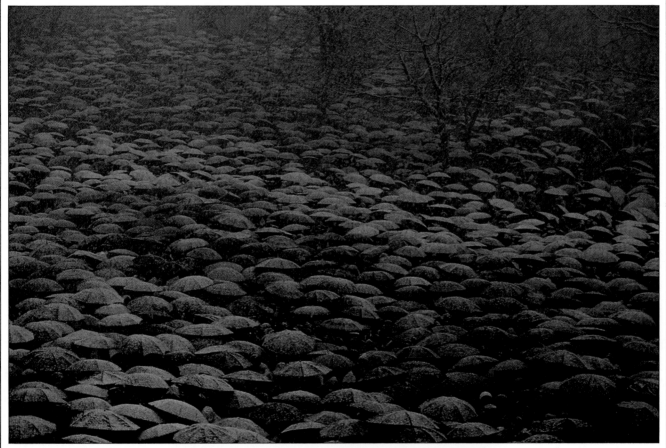

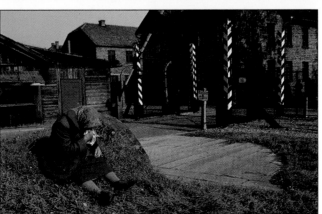

A sea of umbrellas (above) raised against falling snow at an outdoor Mass near Wadowice on Easter Sunday symbolizes the unity and the resilience of Polish Catholicism. Barbey used a 150mm lens from a high viewpoint to exclude confusing details. Splashes of subdued red break up the near-monochrome pattern.

Outside the gates of Auschwitz, the infamous concentration camp of the Nazi occupation years, a woman alone weeps into her handkerchief. Avoiding any novelties of viewpoint, framing, composition or focusing, Barbey let this moment speak movingly for itself.

War

War photography is important not simply as a documentary record for future historians; it is also a means of communicating the tragedy of human conflict. However, an image of war can be so shocking that it repels the viewer without stimulating understanding or compassion. Conversely, there is a danger of belittling the human aspect in a photograph whose impact is primarily esthetic; this danger also applies to less extreme subjects of documentary photography, such as unemployment.

In these pictures, photojournalist Tim Page, who was in Vietnam for much of the 1960s, charts the difficult course between the horribly spectacular and the emptily pictorial. Given the dangers that beset him on all sides, many of Page's views of the war display an extraordinary compositional care. Yet his pictures are also moving and evocative.

Page was already in Southeast Asia when the Vietnam war broke out. He soon found himself compelled by it, and risked his life repeatedly for pictures of the action: he was gravely wounded three times and was once left for dead. The closely framed images on these pages all reflect the intensity of his involvement.

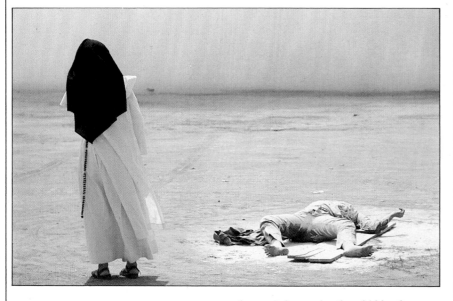

A nun (above), her face hidden from the camera, stands over a recent victim of the war, whose body provides chilling evidence of human cruelty. Page used a 105mm lens to record the scene. The simple but telling detail of the nun's rosary makes an important contribution to this powerful photographic requiem for a dead soldier.

Vietnamese children (right) cling to their mother, who gestures distractedly toward the jungle as a Korean soldier looks on. Page took this picture in the heart of the combat zone, and the image contrasts the disciplined posture of the soldier with the naked bewilderment of a family torn apart by war.

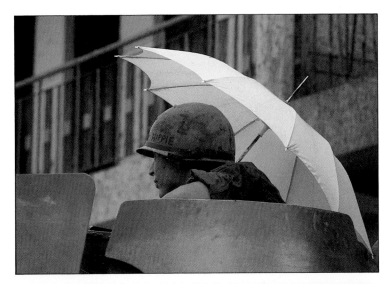

A pink umbrella (right) adds incongruous color to an otherwise austere view of an American soldier scanning a Saigon street from his armored car. The umbrella recalls the ordinary civilian life that war has disrupted.

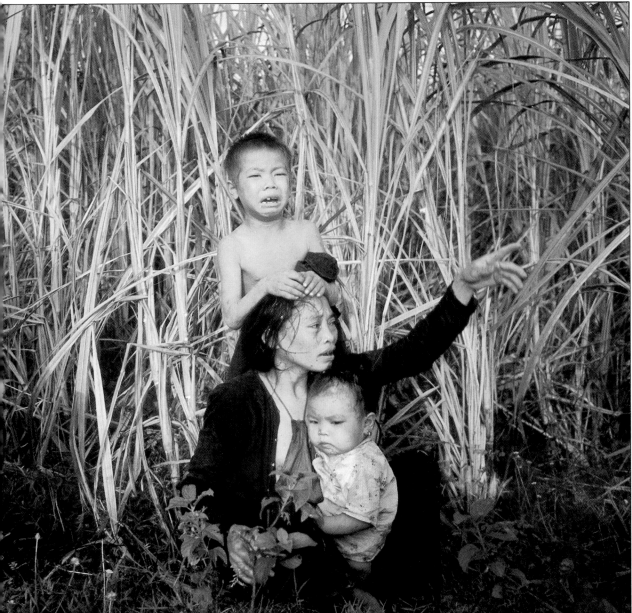

Exotic glimpses / I

Traditional or exotic ways of life surviving in the midst of a modern, Westernized environment are a favorite subject for photographers who like to explore dramatic juxtapositions. But another, equally effective way of treating historic subjects is to isolate them by careful framing to exclude all hints of modernity. The four photographers who took the views of Japan shown here all chose this approach, and achieved a marvelous timelessness in their images, a sense of history transcended.

Japan was an enclosed country, intensely suspicious of foreigners, until it gradually began to open its doors to the Western world in the mid-19th Century. Appropriately, all the photographers represented here emphasized this inward-looking quality, using long lenses, and imaginative viewpoints and framing, to convey the impression of an outsider glimpsing a world locked in mystery. For example, in both pictures of Kyoto on the opposite page, architecture acts as a frame to distance the viewer from the main subject.

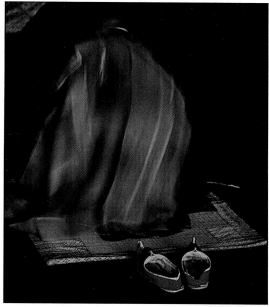

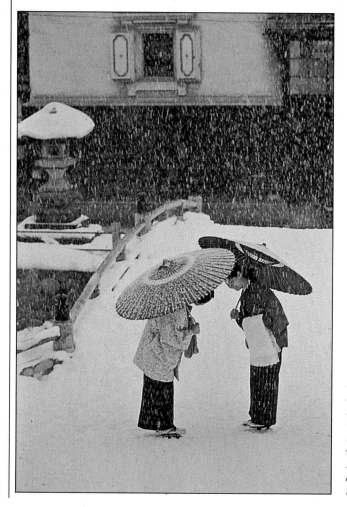

Kneeling in contemplation (above), a Kyoto priest takes on a ghostly form caused by the blur of his robes when recorded by American photographer Elliott Erwitt at a shutter speed of 1/8. The rear viewpoint and the dark temple surroundings intensify the unworldly feel of the image.

A gauzy veil of snow (left) softens the shape and color of two Japanese women conversing under umbrellas. American photographer Burt Glinn saw humor in the way the umbrellas exaggerated the women's bowed attitudes. He took the photograph from a hillside, using a 105mm telephoto lens.

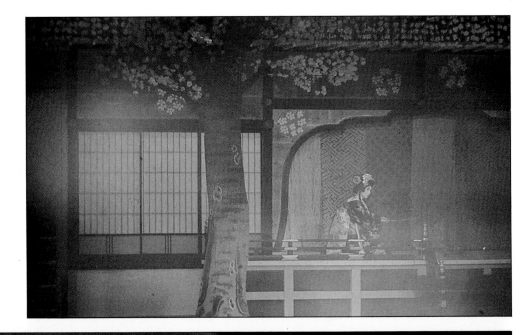

A geisha in a Kyoto tearoom
performs the traditional tea
ceremony. Spanish-born
photographer Francisco
Hidalgo smeared red gel on
the skylight filter fitted
to his 200mm lens to add an
extra dash of exotic mystery.
The long lens compressed the
perspective, so that the woman
seems to be part of an elaborate
two-dimensional pattern that
resembles a stage set.

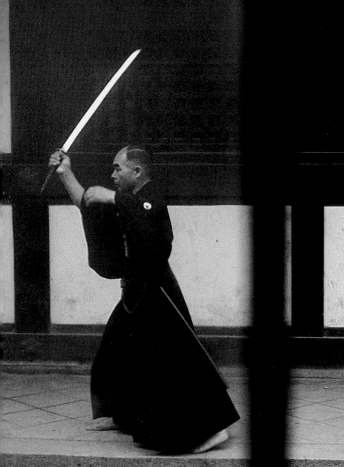

A priest exercises vigorously
with his sword in a picture by
West German photojournalist
Thomas Höpker. The window
struts in the foreground,
blurred by a 105mm lens,
create an impression of secret
observation, while the near-
monochrome hues suggest the
austere discipline of the
Japanese martial arts.

Exotic glimpses /2

In the West, we are used to photographs that identify people; faces, expressions and clothing give clues to character. The pictures on these pages, all taken in Morocco by Belgian photographer Harry Gruyaert, offer instead tantalizing glimpses of people who are almost entirely hidden from our gaze. In most of the pictures, not only the faces but also the bodies are shrouded. Yet these anonymous, elusive figures exert a powerful presence.

Gruyaert has visited Morocco several times to study the place and its people. The strength of his images arises from his fascination with the country, its customs and the relationships between its people and their surroundings. With the women, he often found himself involved in a game: they were hiding from the camera and provoking it at the same time. The rich colors, the quality of the light, the shadows, the intricate details of the settings: all these were used to place the subjects firmly within their context and to evoke mood and depth. In most of the pictures, a wall provides the background, emphasizing the security of an enclosed world.

Mysterious veiled heads (above) are crisscrossed by shafts of sunlight, the bars of shadow echoing the narrow eye-slits in the women's hoods. Gruyaert set his 35mm lens at full aperture for this searching close-up view to register the foreground figure slightly out of focus and lead the eye to the figure behind.

A distant figure (above) blends into the pattern of shadows on a sunlit wall. Strong color, texture and shape give greater weight to the foreground of the composition, emphasizing by contrast the elusive, unattainable quality of the figure. The lines of the palm trunks convey depth and provide a natural frame.

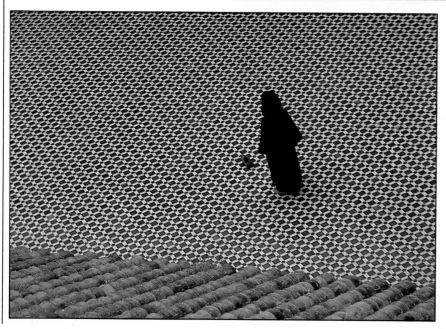

A figure in black (left) stands barefoot in the courtyard of a mosque in Fez. The dynamic pattern of the tiles and the stillness of the worshipper create a tension that gives the image tremendous power. The angled, overhead view, framed to include the steep roof, conveys the sense of privacy of an enclosed space.

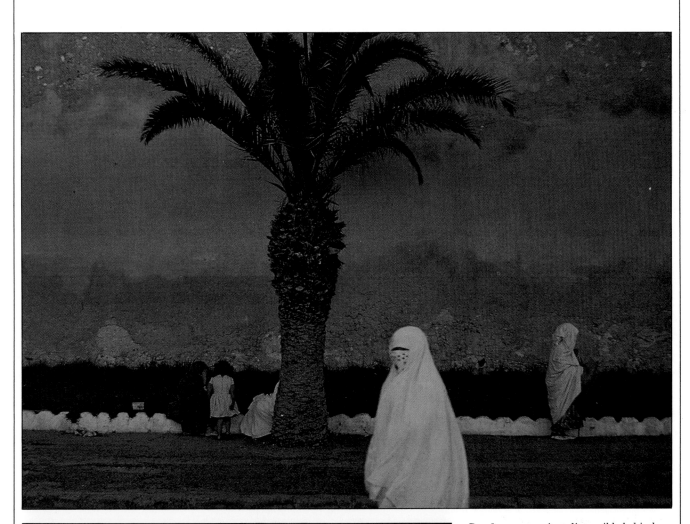

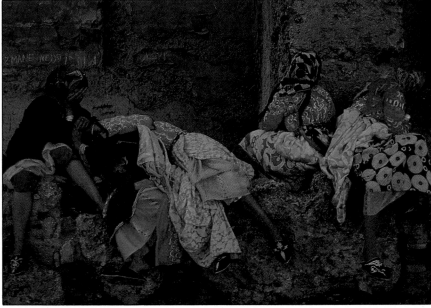

Dark eyes *are just discernible behind a heavy veil as a passing woman turns to watch the camera (above). The simple shape of the white robes is echoed in the background figures and in the low parapet behind them. Horizontal bands of soft color create a mood of serenity and help give visual unity to the image.*

Marrakesh women *(left) shield their unveiled faces from the camera. Their different reactions produce an intriguing image in which the arrangement of patterns and colors against the rough textured wall at first confuses the eye. To bring out the richness of color and detail, Gruyaert underexposed by one stop.*

At work in industry

Photographing people at work in industry presents special challenges. Technology has fragmented most jobs into tiny parts, so that a single photograph can show only a little of the productive process; and most industrial workplaces are complex environments, crowded with confusing detail.

These pictures show some of the ways in which experienced photographers tackle such problems. In the two photographs below at left, a low viewpoint has eliminated much of the clutter that litters a plant or building site. The converging verticals caused by the upward-pointed camera also add a feeling of dynamic activity, especially to the top image.

The picture below at right has been simplified in a different way, by using bold lighting and careful framing. And by allowing the finished product to occupy over half the composition, and keeping the dimly lit figure of the worker small in the center, the photographer has conveyed the belittling scale of the paper-making process.

Construction workers, lit by industrial floodlights, stand out against the dark. Flash would have eliminated the green color cast but would have spoiled the mood, so the photographer, Burt Glinn, chose available light.

An oil-rig worker makes a late-night inspection – his flashlight beam drawing attention to the scene's only human element. Tungsten-balanced film emphasized the color contrast in this picture by Jean Gaumy.

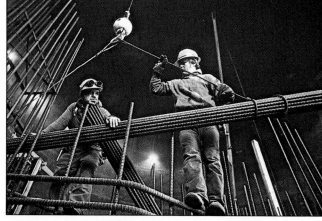

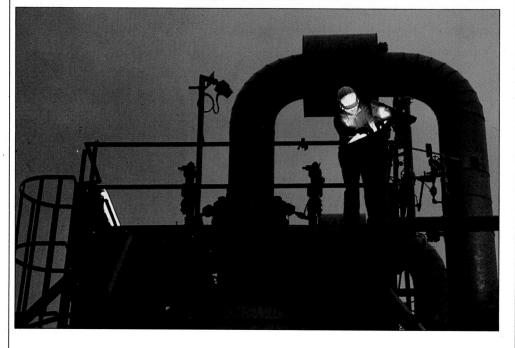

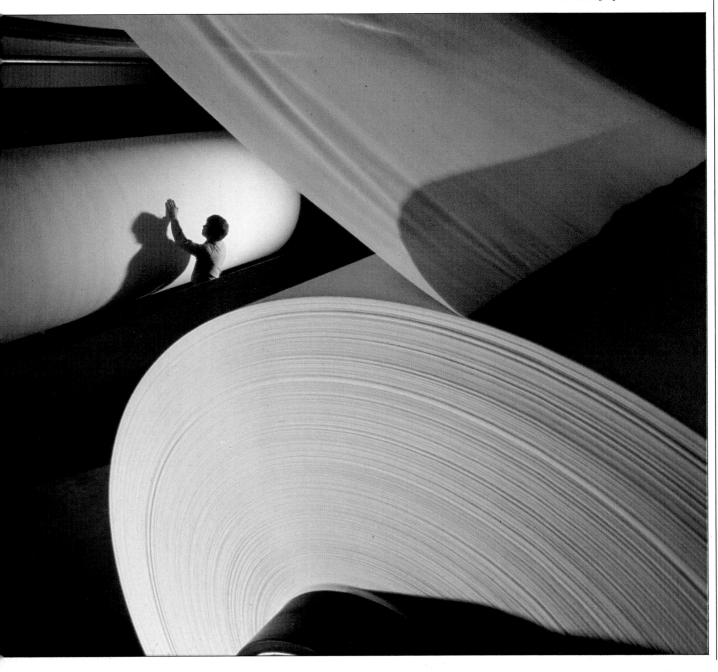

Rolls of paper dwarf the tiny figure of a mill worker in a picture by Paul Fusco. In order to exaggerate the huge scale of the rolls, the photographer used a wide-angle lens, positioning the camera just a few feet from the nearby spool.

At work on the land

Many artists have drawn inspiration for paintings or drawings from rural labor: a stroke of the brush hides the dirt and sweat, and creates a nostalgic idyll. The camera, too, can isolate the picturesque aspects of farming to suggest a harmony between man and nature, as the images here show. The scene at bottom left, with its stooping figure, reminded photographer John de Visser of a painting by the French artist Millet. To strengthen the similarity, he chose a high viewpoint that excluded any signs of the 20th Century, then used the compressed perspec-tive of a telephoto lens to flatten the image and further increase the resemblance to a canvas. The picture below at right has a similar painterly quality, but here it springs from the mist-muted colors and the slanting rays of warm morning light.

Another way to present a romantic view of farm life is to concentrate on the bond of cooperation among workers in the fields. In the picture below at left, the variety of postures and colors creates an image that is full of vivacity and a sense of the joy of rural labor.

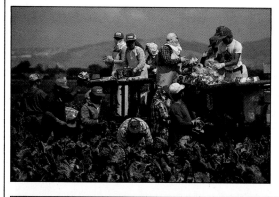

Toiling in the sun, California farm workers gather and pack cauliflowers (left). To intensify the brilliant splashes of color that their clothing made in the sea of leaves, photographer Mireille Vautier underexposed by half a stop.

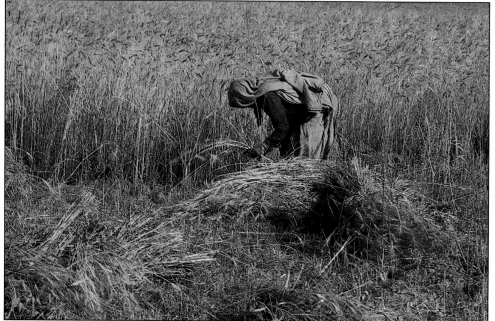

Harvesting by hand (above), an Indian farmer follows a ritual that has continued unchanged for centuries. A No. 81C filter over the lens enhanced the colors of the scene, giving the picture the mellow tones of an old oil painting.

Loading a cart with fertilizer before spreading makes an almost idyllic scene when transformed by early morning sunlight and by careful composition. The photograph was taken by Philip Jones Griffiths on his travels in Korea.

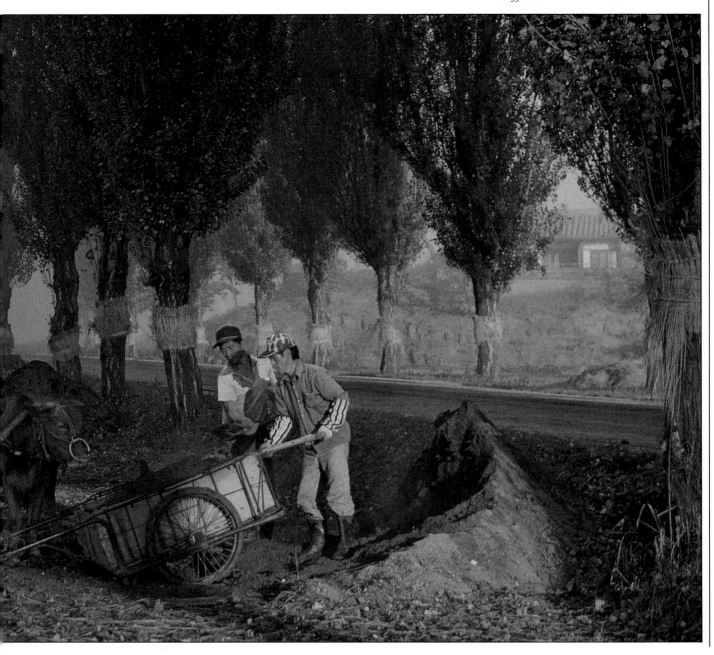

Silhouettes

Silhouetting reduces subjects to graphic simplicity because the limited range of tones and high contrast throw emphasis on line, shape and pattern. The three photographers represented here have each taken the graphic power of silhouettes to an extreme by deliberate use of very high contrast – at least six stops – between the light and dark areas, with virtually no intermediate tones. The pictures were all taken on color transparency film, which is more contrasty than color negative film.

The picture below by Thomas Höpker is in the classic head-and-shoulders format; but backlighting through a paper screen has reduced the subject to a simple outline, accentuating the slightness of the figure, the graceful column of the neck and the intri-cate formality of the decorated hair. The stylized treatment strongly evokes a particular culture. Alex Webb's photograph at the top of the opposite page, taken in Uganda, uses the contrast between blocks of dense shadow and brilliant light to concentrate attention on the distant figures. He is fascinated by what he describes as the "hot, shadow-crossed light" of tropical regions such as Africa, the Caribbean and Mexico. Here, the almost tangible weight of light and shadow and the fragmented shapes create a disturbing image with intimations of chaos. The gentler vision of Ernst Haas is revealed in the large picture below. Against the setting sun, groups of people feeding pigeons in Venice's St. Mark's Square are linked in a flowing pattern.

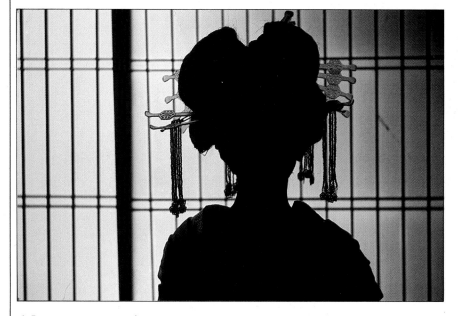

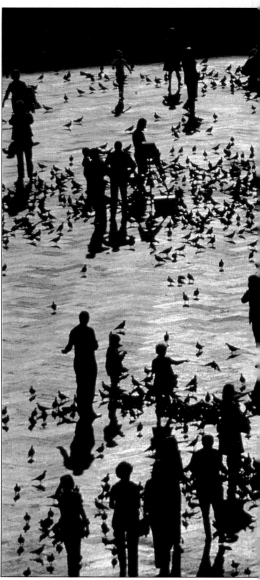

A Japanese woman in elaborate traditional costume is outlined against a simple translucent screen. Although almost all detail is obscured, the characteristic hair style and ornaments give identity and context to the figure. Texture and color in the hair combs add variety to the flat, two-dimensional shapes.

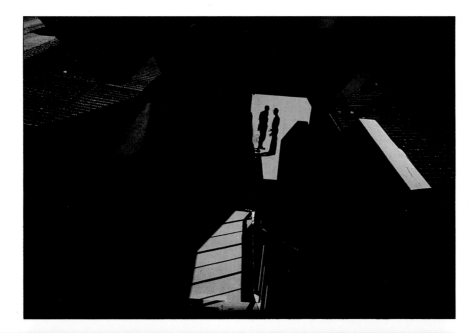

Two figures on a railroad platform are enclosed in a jigsaw pattern of solid light and shadow. An oblique viewpoint across the roofs created the complex, angular shapes that suggest tension and intrigue. Exposing for the midtone of the platform heightened the contrast between dark figures and white-hot light.

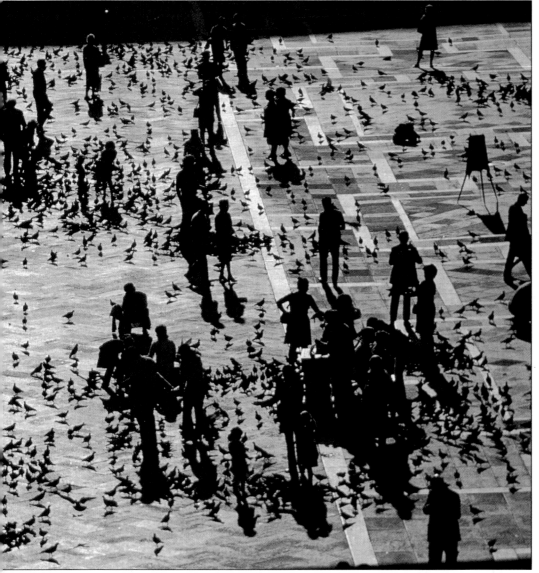

Pigeons and people fill St. Mark's Square, Venice. A high viewpoint and strong backlighting from a late low sun combine to create this graphic image brimming with life and movement. Elongated, sharp-edged shadows merge into the figures that cast them; the rippling shapes of the birds are echoed in the pavement pattern. Converging lines and a long background shadow draw the eye back and forth to scan the scene.

Competitors

The human element of competition gives an exciting edge to sports photography. But in the flurry and confusion of a big event, it can be difficult to find a viewpoint on a subject that creates a strong, coherent image. By understanding that competitors are often essentially alone in their struggle, professional sports photographer Eamonn McCabe succeeds time and again in capturing perceptive and telling images – sometimes in the thick of the action, but just as often at quieter moments, before or after an event.

The picture of the diver below and the one of the racing driver on the opposite page both rely strongly for their visual impact on the pattern created by an overhead view. At the same time, the isolation of the subjects suggests the intensely personal concentration of a competitor.

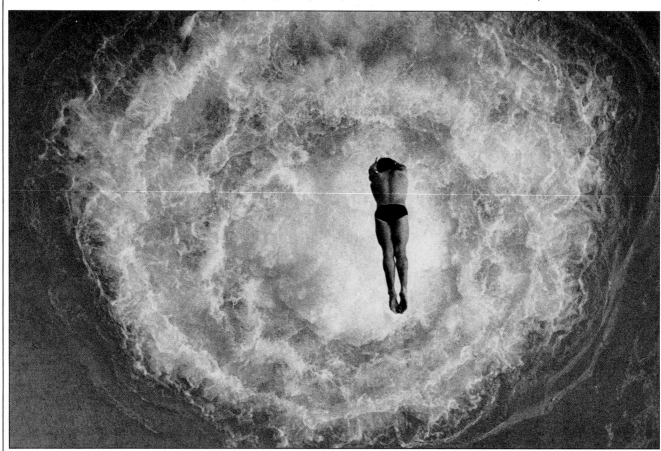

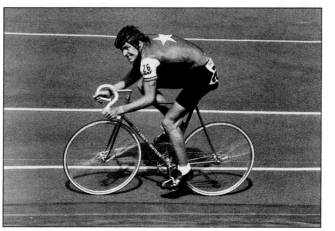

A diver *(above) plunges toward a cushioning whirlpool in a practice pool. The ring of foaming white water makes a dramatic frame for the subject and emphasizes the clean, arrowlike movement of the dive. To compensate for poor lighting, McCabe pushed ISO 400 film by one stop, setting his 35 mm lens at 1/60, f/2.8. The shutter speed caught the diver sharply but blurred the water's motion, effectively contrasting the well-defined figure with the surging background.*

Racing against time *(left), a cyclist speeds around a track. The competitor's effort is clearly shown in his knitted brow and clenched teeth, and in the attitude of his body, pressed forward to expend every last ounce of strength. Using ISO 400 film, the photographer closed in with a 105 mm lens and panned the camera at 1/250, f/16 to record the subject crisply and blur the wheel spokes.*

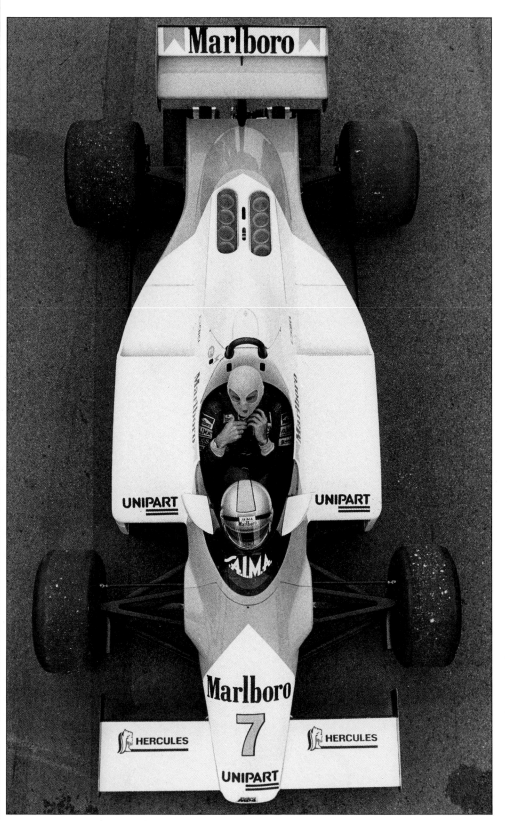

Tucked into his car, a driver adjusts his mask before a race at Silverstone, England. Because this was a practice race, McCabe had the chance to look for the very best vantage point. He chose a viewpoint from a footbridge over the track to reveal the car's distinctive shape. The pattern of curves within curves reinforces the close relationship between the driver and his machine. The photographer used ISO 400 film and set his 35mm lens at 1/125, f/5.6.

43

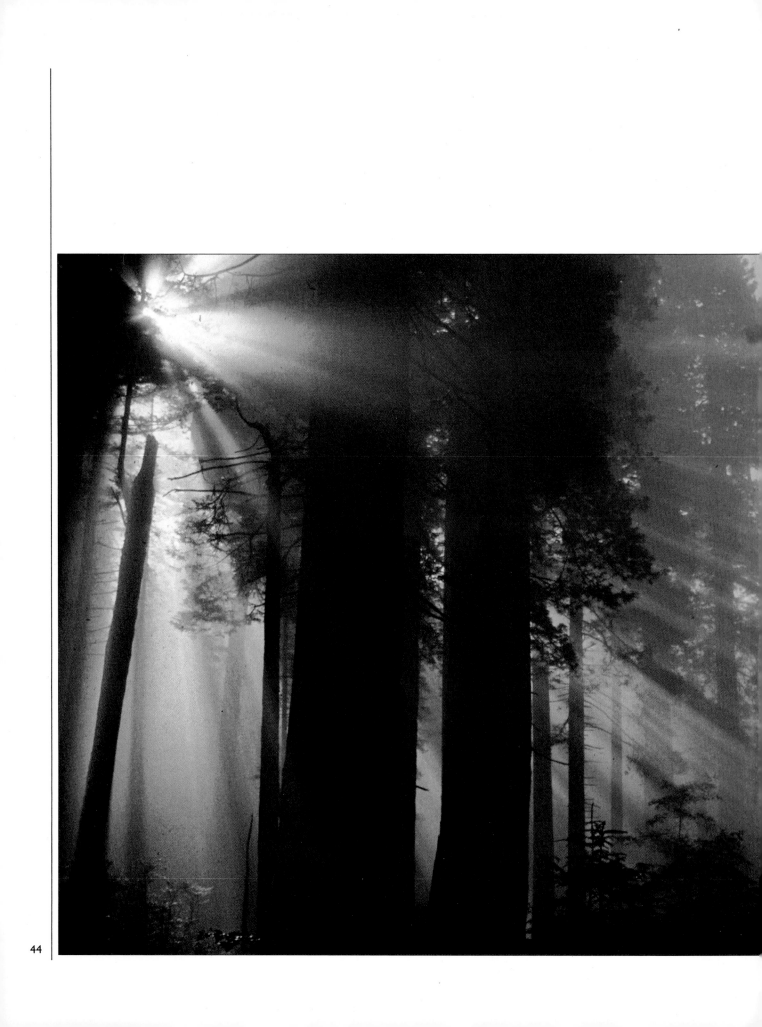

LANDSCAPE AND LIGHT

Of all subjects, landscape offers perhaps the greatest challenge to the photographer. You cannot control the untamed grandeur of land and sky by placing a floodlight here, a reflector there, to alter the way that light falls on a field or lake. True mastery of landscape photography means learning to think for the camera, recognizing the juxtapositions of shapes and light that will make good pictures; it also means knowing when a scene of natural beauty will lose too much of its appeal if reduced to the proportions of a postcard-size print.

The appeal of landscape lies partly in its mercurial character: as the seasons change, the colors of the land change from green to gold, and then to the monochromatic starkness of winter trees and frosty land. The cycle of night and day brings swifter changes; effects like the shafts of light in the image at left may last for only a few seconds.

The following pages illustrate just a few of the countless approaches that experienced photographers take to landscape. Each interpretation of a range of basic themes derives its freshness and impact less from special techniques or tricks than from the individual vision of the photographer who took the picture.

Gilded sunbeams cut through morning mist in a forest glade, making a brilliant contrast with the stark upright shapes of the redwoods. To preserve the delicate tracery of the sunlight, photographer Dennis Stock metered for the bright highlights, thus allowing the trees to turn into silhouettes.

The human landscape

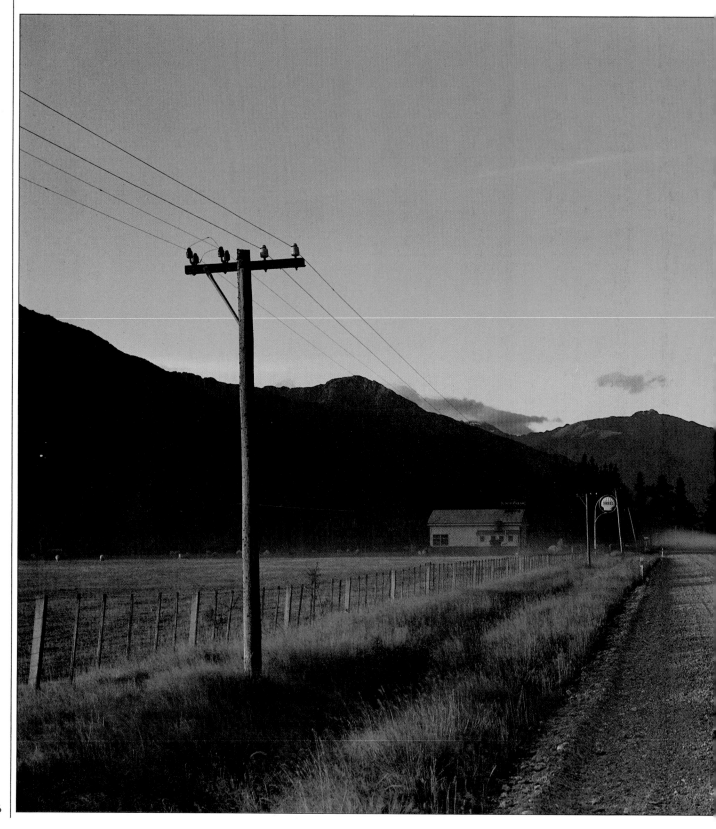

A gravel road leads past an isolated gas station, its bright yellow sign picked out by the fading afternoon light. Kenneth Griffiths came upon the scene while driving through rural New Zealand and hurried to position his 4 × 5-inch view camera on its tripod before the sun set. He used two filters – a neutral gray graduated filter to darken the sky and a pale yellow color 81C to emphasize the warmth of the light. The exposure was five seconds at f/32 on ISO 64 film.

A white gate and a red streak from a passing car contrast with the blue of twilight (right). An exposure meter reading from the sky ensured that the ground remained dark, and thus made the red trail, obtained by a slow shutter speed of 1/8, stand out more clearly.

A discarded boot tops a low fence, symbolizing a losing battle against the elements (right). A low viewpoint lifted the fence within the frame, so that the boot towered over the bleak surroundings.

One classic approach to landscape photography is to exclude all evidence of human activity. However, for many of us such uninhabited landscapes are either rare or uninspiring. The photographers whose work is shown here adopted a different strategy. By including signs of everyday activity, they suggested a tension between natural and artificial elements.

In the picture at left, Kenneth Griffiths built his composition around the theme of communications, including such humdrum features as telephone wires and advertising signs, which a less original photographer might shun. Recent human presence in this picture makes itself felt only indirectly, as it does in the one immediately below by John Freeman. In one image a distant cloud of dust, and in the other the red trail of taillights, suggest that an auto has recently disturbed the tranquility of the scene.

In the picture at the bottom of this page, John de Visser used manmade elements very differently – to hint at the temporary and superficial nature of the human influence on the landscape. The rusted fence and weather-beaten boot imply that the day when nature reclaims the scene is not far away.

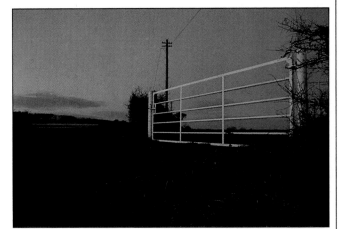

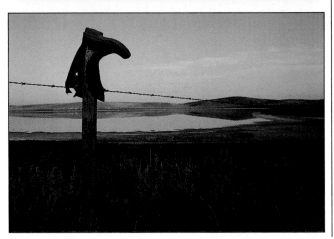

Buildings in the landscape

Nature rarely makes a straight line. Hilly horizons undulate gently, mountain ranges stretch jaggedly upward, and even tall evergreens bend and twist slightly. In buildings, the opposite is more usual: straight lines, perfect squares and exact right angles replace random natural forms. Juxtaposition of these two very different environments – the organic shapes of nature and the regularity of buildings – can create contrast and diversity that add strength to a landscape image.

To make the most of such contrasts, the photographers represented here chose their viewpoints carefully. For example, the picture at top right by

Ernst Haas owes much of its success to the low camera position. Silhouetted against the sky, the sawtooth pattern of treetops contrasts dramatically with the clean lines of the church. And in the image below at left by Bruno Barbey, an aerial view reveals the shape and function of the ranch houses and the wheel-like sheep pen.

Besides varying the pattern and texture of landscape, buildings can also provide a sense of scale. For example, without the rough-hewn Moroccan village in the picture below it would be impossible to judge the distance between the foreground figures and the far-off hills.

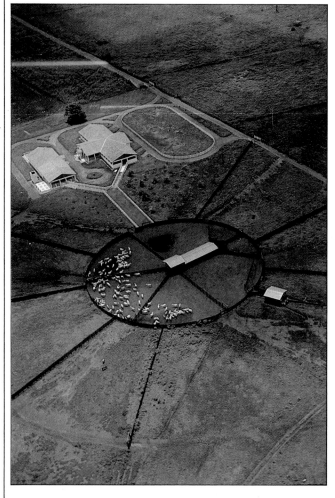

An animal shelter forms the hub of a sheep pen on a Brazilian ranch. To get a good view of the scene, the photographer asked the pilot of the aircraft in which he was traveling to bank and circle the farm.

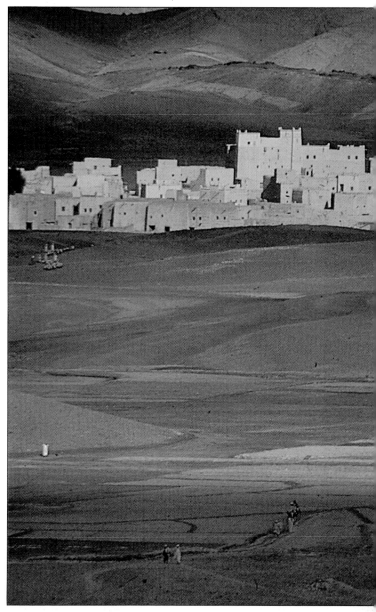

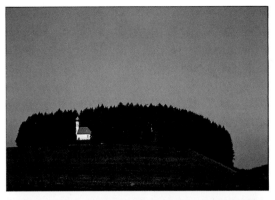

A white church nestles on a hill, its paintwork made more brilliant by the dark background of trees. Ernst Haas noticed this unusual effect from a car in which he was a passenger. He asked the driver to stop and captured the image on film before the light changed.

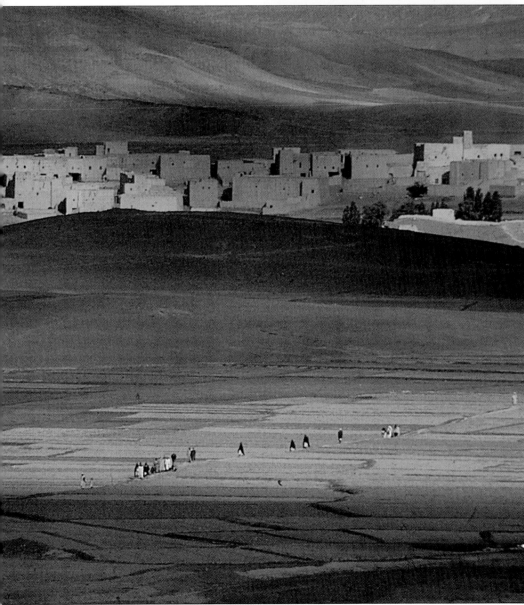

Dun-colored buildings straddle a rolling plain, their rambling pattern echoed by the figures in the foreground. Blue sky would have spoiled the dusty, monochromatic look of this picture by Harry Gruyaert.

The enclosed landscape

The experience of landscape is not always one of distant horizons. Wild places can also be intimate, hemmed in by nature, even rather stifling in mood. As these two pictures show, you can create powerful landscape images by concentrating on this sensation of enclosure. The photographer, David Muench, has captured the atmosphere of dank undergrowth and forest gloom by excluding any features that might suggest distance and openness. The tiny figure, dwarfed by the green surroundings as he looks down on the waterfall in the view below, only intensifies the feeling of rampant organic growth.

Another factor that makes these pictures so evocative is their remarkable intensity of detail, which encourages our eyes to scan back and forth across the image and pick out every leaf and frond, re-creating the scene as it appeared to the photographer. Muench achieved this richness by using a tripod-mounted large-format camera and by stopping the lens down to a very small aperture. With a 35mm camera, it is possible to get a similar wealth of detail with fine-grain transparency film such as Kodachrome 25, though a tripod and a small aperture are still vital.

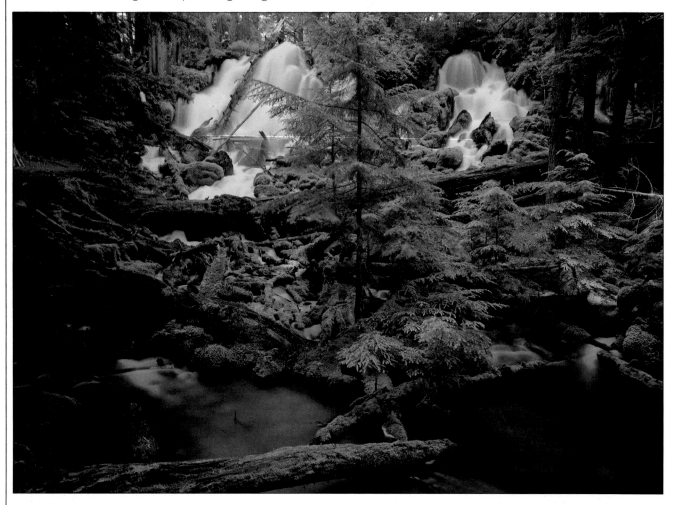

A cascading waterfall on Oregon's Umpqua River dissolves into an ethereal mist of blue and white. The dim light, with the aperture set to f/64 for maximum depth of field, necessitated a 10-second exposure, which blurred the water into soft, rounded forms.

Festoons of moss dangle from trees in Olympic National Park, Washington. The light falling on the scene was tinted green by the canopy of leaves, so the photographer used a No. 10 red color compensating filter to prevent a color cast.

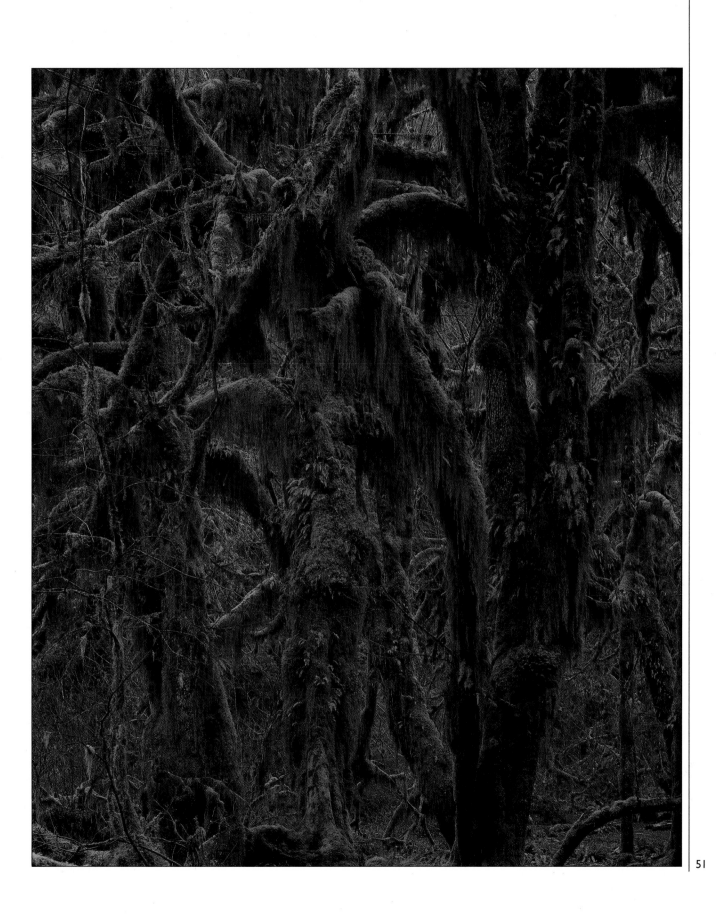

Snow scenes

Snow completely alters the mood and character of a landscape. Colors are simplified, and familiar features are hidden or take on strange new forms. To photograph snow scenes successfully, therefore, requires a fresh appraisal of compositional elements and lighting, and particular care with exposure.

Ernst Haas and Pete Turner, whose pictures are shown here, both made use of the reflective quality of snow to create abstract images with strong graphic impact. Shooting with the sun in front of instead of behind the camera filled the frame with shadowed snow, reflecting the bright blue sky.

Generally, it is necessary to overexpose snowscapes by one to one-and-a-half stops, to retain the sparkling whiteness of sunlit snow. However, the presence of extensive shadow areas in both of these pictures made average or underexposure more appropriate. In the Pete Turner picture opposite, underexposing emphasized the deep blue of the drift, in contrast to the sunlit ridge. A telephoto lens flattened perspective. Haas used shadows differently, below, to bring out sculptural forms.

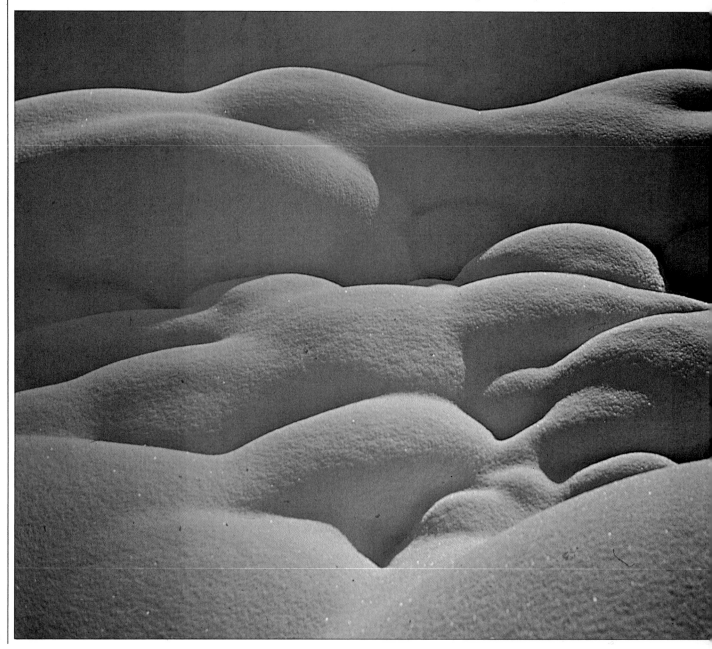

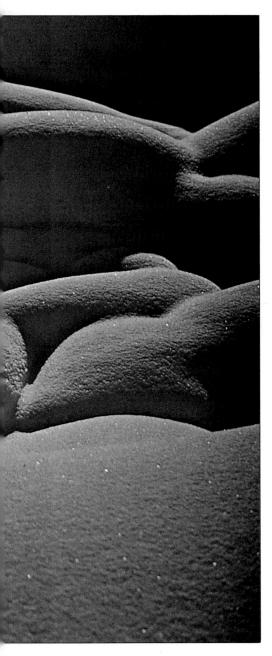

The white spear *(above)* *of a snowy ridge creates a dynamic division of the frame. Turner shielded his lens and photographed toward the low sun to obtain the deep blue shadow stretching below the ridge. By underexposing and then duplicating the transparency, he increased the saturation of the blues.*

Snow-covered rocks *(left) in a shallow riverbed resemble the soft, rounded contours of human forms. Haas pointed his camera toward the sun to allow shadow tones to dominate the scene, and used average exposure to prevent the bright highlights from burning out. The fine textural detail and the well-modeled shapes give a strong three-dimensional quality to the photograph.*

Sculpture in the landscape

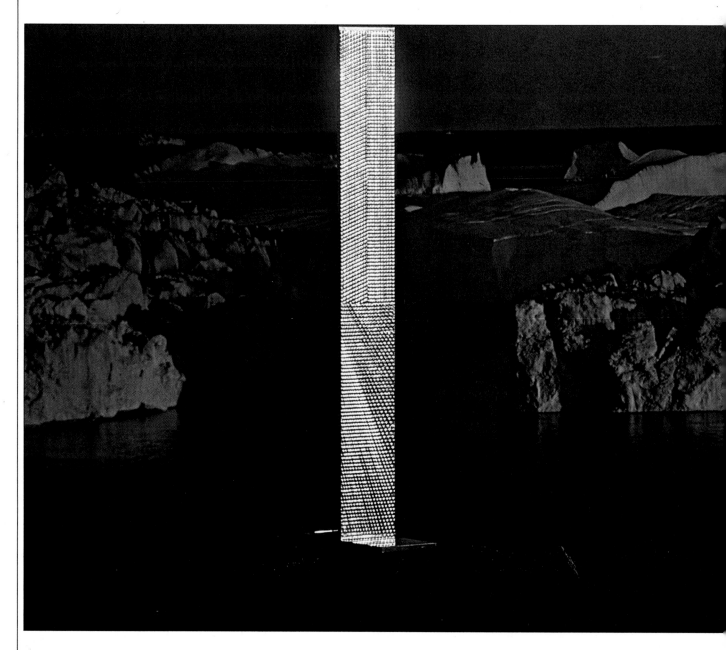

Everyone who stands alone in a natural wilderness feels a sense of wonder, and many try to capture this elusive quality on film. Few amateurs, though, consider introducing extra elements into the landscape to concentrate its drama and grandeur. Thomas Höpker did just this in creating the images shown here, and succeeded in crystalizing some of the awe that wild places evoke.

Höpker worked with West German sculptor Heinz Mack to make these unusual pictures. The two men traveled to the Sahara and later to the Arctic Circle, in a truck laden with materials, tools

and tents. They did not take finished sculptures with them; instead Mack made his constructions on the spot to harmonize with the surroundings that he and the photographer chose together.

The strength of the images lies not in the sculptures themselves – they are relatively simple creations – nor in the remote landscapes, but in the way the two men used the reflective surfaces to echo the surroundings and make them reverberate with light. Such an experiment is open, on a less ambitious scale, to anyone: all that is needed are mirrors and sunlight.

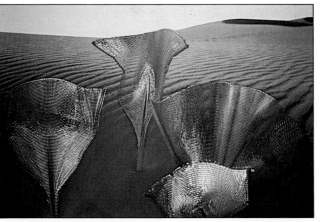

Silvery bushes sprout
from the sand in the Sahara.
Höpker angled the shiny
honeycombed metal fans
so that they reflected both
the pale blue of the sky and
the yellow of the sand.

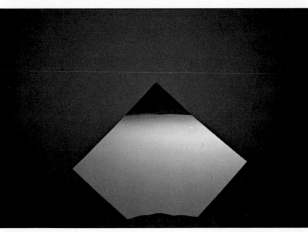

A glowing square – in
fact simply a curved mirror
– protrudes from a sand
dune, its reflective surface
catching the dusk's fading
light. The curve in the
mirror has inverted the
reflection of the horizon.

A blue arrow (below) –
actually polished metal
reflecting the sky – directs
the viewer's eye to the
foil-clad sculptor. Höpker
underexposed by one stop
to enrich the yellow of
the sunlit sand dunes.

A shiny column (above)
of highly polished metal
alloy glows with arctic light
in Disko Bay, Greenland.
To enhance the brilliance
of the reflected midnight
sun, the photographer
followed a reading from the
ice, knowing that the sea and
sky would provide an
effective dark background.

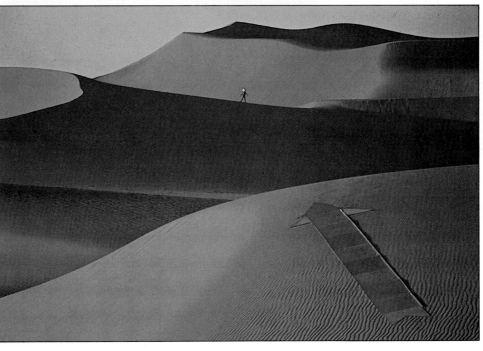

Animals in the landscape

Living figures can add movement and interest to an otherwise empty landscape. People, however, may command too much attention in a scene, particularly in wild regions, where the human presence may seem out of place. Animals, on the other hand, can provide a focus for the eye without upsetting the balance of a landscape composition.

The pictures here, each taken by a master of land-scape and nature photography, have the same subject matter and similar settings. Both photographers chose wild horses in their natural environment for mood and resonance and used color skillfully to strengthen composition. But whereas Ernst Haas, in the picture opposite, used fluid shapes to create vitality, Dennis Stock, in the image below, used crisply defined shapes for a more static image.

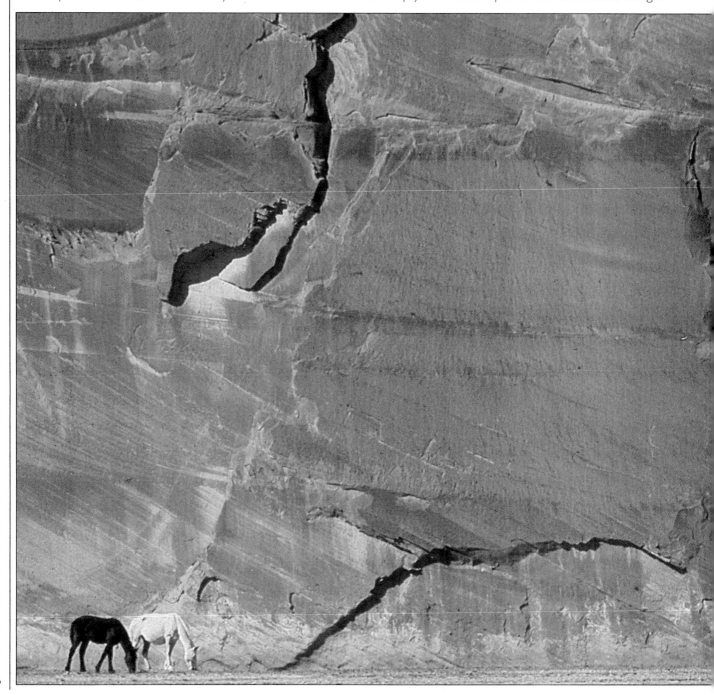

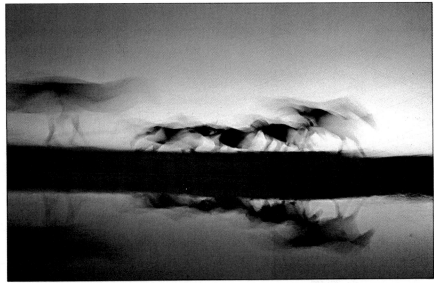

Wild horses (above) *gallop across the Nevada plains. To obtain this image of fleeting movement, perfectly balanced by the still reflection in a lake, Haas took advantage of the backlighting from a late-afternoon sun and panned his camera to follow the fast-moving subjects during a long exposure of 1/5 at f/16.*

A pair of mustangs (left) *grazes on the sparse vegetation of the Arizona desert. The tiny horses, placed in a corner of the frame, accentuate the scale and sheerness of the wall of rock. The shapes and colors of the horses are echoed in the shadow-filled crevices.*

Abstract horizons

Most photographers find it hard to resist the romantic appeal of landscape, and their pictures may aim to capture the beauty of a sunrise or evoke the sensuous roundness of rolling green hills. But Italian photographer Franco Fontana rejects this literal, nostalgic approach to the land. Positively exploiting the limitations imposed by the flat surface of a photograph, he uses beaches, fields and hilltops as broad, horizontal areas of color, often conjuring up abstract or semi-abstract shapes in remarkably geometric compositions.

Applied too methodically, this formal approach could easily lead to repetitive or stereotyped images. However, Fontana, unlike the numerous

A swath of brown cuts across a landscape of lush meadows, contrasting with the ribbon of white formed by the misty sky. To ensure that his picture maintained the delicate balance between dark and light areas, Fontana bracketed his exposures.

The forest's edge divides sky and land with a strip of mottled green in Fontana's view of a poppy-strewn field near Ravenna, Italy. To reduce the sense of depth and distance in the image, Fontana set his zoom lens to 200mm and cropped out all foreground detail.

imitators of his style, recognizes this and often modifies his minimalist style to take in realistic landscape elements. For example, the two pictures here use clumps of grass and irregular bands of trees to break a symmetry that might otherwise look too neat.

Fontana's working methods are simple. He loads his camera with transparency film, which he under-exposes to increase color contrast and saturation. He usually uses a telephoto lens because this allows him to stand some distance from his landscape subject – often slightly above it – and to exclude extraneous details that would break up the regular zones of color. The final stage is careful printing, to make hues still more vivid.

Storm light

Stormy weather reverses the tones of land and sky, as dark clouds loom on the horizon and shafts of sunlight create sparkling patches of brilliance on the landscape beneath. The suggestion of an impending downpour can add a sense of breathless expectancy. The pictures here show how three photographers have harnessed this excitement.

Light trapped by storm clouds can transform ordinary scenes, such as the tree-lined road below at left, with startlingly beautiful hues. However, unusual lighting effects pass very rapidly: photo-grapher Dennis Stock had to act quickly, because as soon as the shadow of the clouds engulfed the trees, the contrast between light and dark disappeared, and the picture would have looked flat and dull.

With landscape subjects that are themselves unusual or spectacular, storm light can redouble the impact of the picture, especially if you base your meter reading on the highlights in the scene. The drama of a dark sky can add an unusual twist to a much-photographed view, such as the natural wonder below at right.

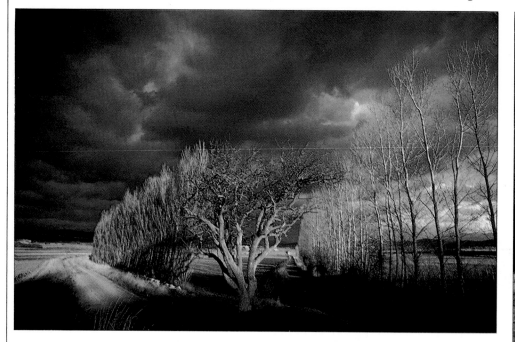

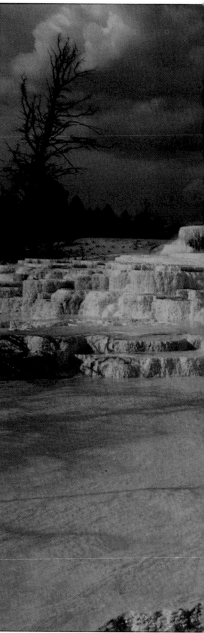

A row of vividly lit trees (above) marches toward a stormy horizon. To strengthen the perspective and to ensure that the rolling clouds dominated the frame, the photographer used a 28mm lens and pointed the camera slightly upward.

White salts from a hot spring in Yellowstone Park glow with unreal brilliance against a background of dark clouds. To maximize the contrast in the scene, and to darken the clouds still further, Mireille Vautier took a meter reading from the sunlit foreground.

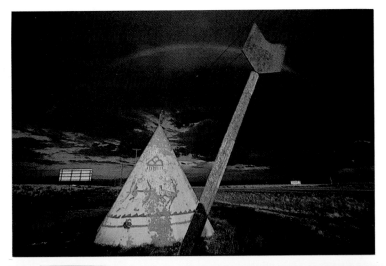

A novel advertisement for a roadside restaurant enlivens a flat New Mexico landscape. By careful choice of camera position, photographer René Burri united all the scene's disparate elements under a rainbow to relieve the ominous darkness of the clouds.

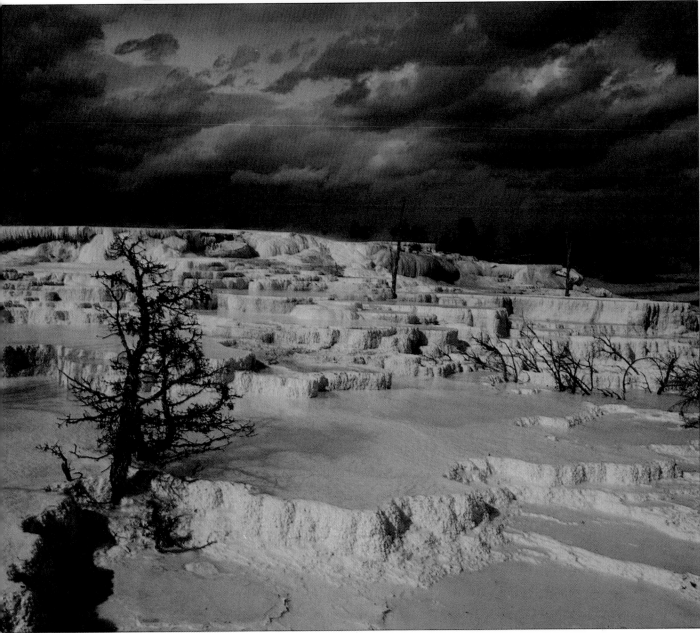

The desert's moods

Nowhere is the force of the elements more apparent than in a stark landscape like a desert. Wind, water and weather erode the surfaces of rocks and mountains, and shift sand into massive dunes and hard ridges. Because vegetation is sparse or nonexistent, the marks of these natural forces are clearly discernible in the patterns and textures of the land. Some changes are wrought over thousands of years. But desert landscapes alter visibly day by day as well, not only as a result of high winds that whip up the sand and uproot scrub, but also because changes in

the light have a dramatic effect on exposed places.

Ernst Haas is renowned for the dynamic energy that he instills into his images, even when the subject is conventionally considered to be static. Both in the graphic composition below at left and in the large picture below, movement makes one strongly aware of the elements. The photograph at the top of the opposite page, by René Burri, evokes a different mood, one of barren stillness and cold. Here, the color of the light was crucial: the same scene at noon would have suggested baking heat.

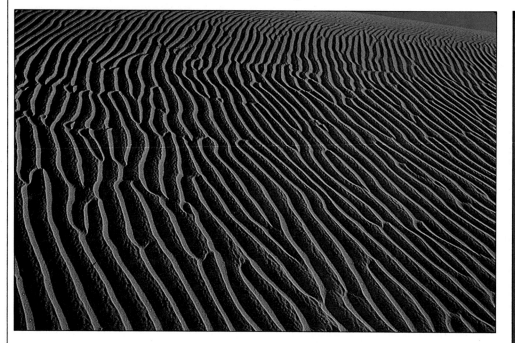

A maze of ridges (above) creates
a restless pattern that stretches as far
as the eye can see. The low viewpoint
includes just a small triangle of sky
at the top of the frame to give context
to this strongly abstract composition.
Low oblique light picks out the subtle
texture of the grooves and ridges. To
emphasize vast distance in the narrowing
lines, the photographer used a 28mm lens.

Smoky clouds (right) hang over
a sandstone crag in the Utah mountains,
suggesting the movement of the wind that
has helped fashion the bare rock. Sunlight
striking the side of the crag provided
fine modeling and highlighted a human
trace: Indian signs carved in the rock.
Haas closed in with a 90mm lens and used
a polarizing filter to darken the sky
and give definition to the cloud shape.

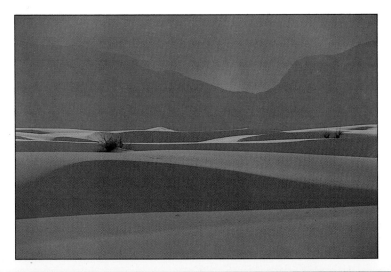

White dunes in New Mexico (left) are reminiscent of a snowscape in the cool light of early morning. A 200mm lens drew the distant mountain range forward, linking together the separate planes of the scene and their subtle gradations of tone. To retain the purity of the dunes, the photographer took a reading from the shadows and bracketed exposures.

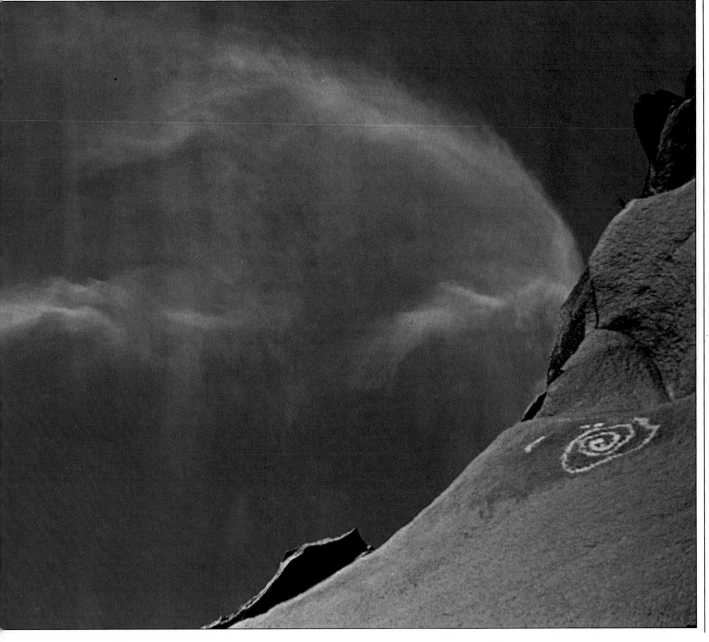

Subdued color

Delicate, subdued colors give landscapes a mood of serenity and stillness. Some scenes are composed of inherently subtle hues. But more often the photographer who seeks this effect must create it by carefully selecting viewpoint and exposure.

The photographs shown here were taken in different countries of Europe and reflect the personal styles of their photographers. But they share a limited color range that links together elements and produces an overall harmony. The lighting conditions prevailing at different times of year, and even in the course of a single day, can affect colors drastically. Landscapes that contain brilliant, saturated colors in the light before a storm or when shadows are strong in mid-afternoon may appear almost ethereal early or late in the day, when a weak, low sun may bathe a whole scene in golden light. Viewpoint also can limit color. The high viewpoints of these pictures excluded the sky, which would have introduced contrasts of color and tone.

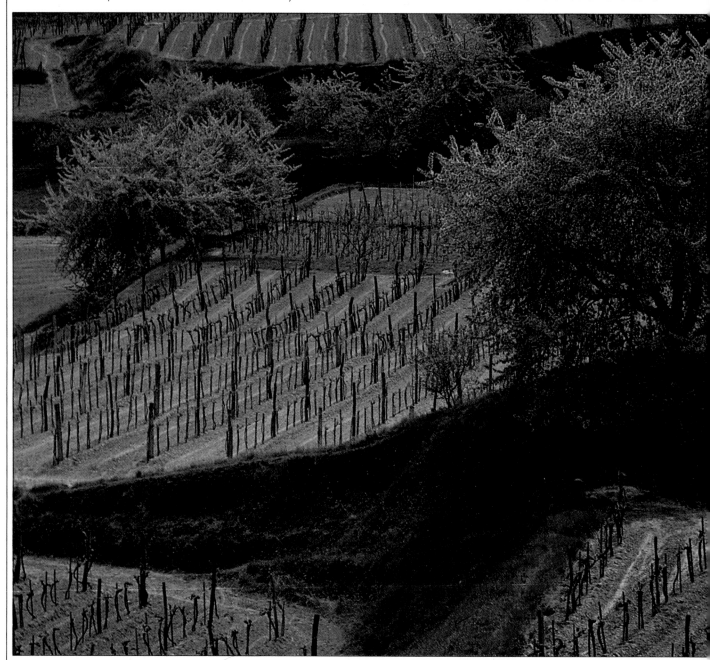

Rows of staked vines (below) stretch
back into the distance in an Austrian
vineyard. The varied, irregular shapes
of the fields, bordered by grassy slopes
and trees in blossom, form a harmonious
color pattern. Photographer Erich Lessing
used a 135mm lens to compress perspective
and draw the patchwork colors together.

Loosely stacked sheaves (below)
dot the fields of stubble on a hillside
in Tuscany, Italy. Sonja Bullaty
accentuated the soft, pastel effect by
taking the picture with a 105mm lens in
clear but diffused midday light that
retained the muted hues and recorded
fine detail on Kodachrome 25 film.

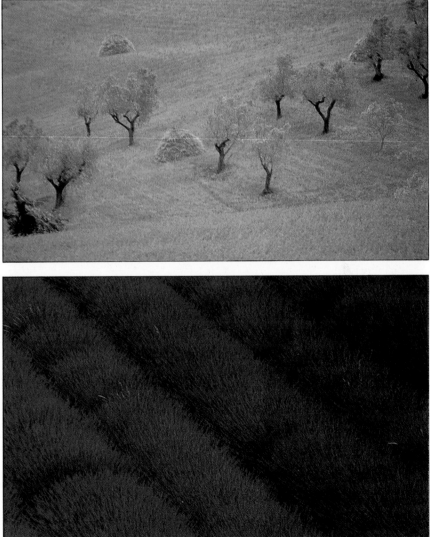

A lavender field in the French
region of Provence (above) provides a
subtle composition of complementary
hues. Dennis Stock used a 500mm lens to
close in and fill the whole frame with
the subject. From a distance, the blues
and greens appear to soften and merge.

65

Shorescapes

The border of land and sea can be the most fascinating of all landscapes to photograph, partly because it is subject to dramatic change over short stretches of time. The constant shift of light, sky and tide unfolds a large-scale landscape narrative; and there is also the thought-provoking, sometimes poignant spectacle of human beings and their artifacts dwarfed by the magnitude of the ocean.

Such qualities help to explain why the shoreline of Cape Cod, Massachusetts, holds such an appeal for New York-born photographer Joel Meyerowitz, who took the pictures shown here in the summer of 1977. Before that Meyerowitz was known for urban photographs taken in the "snatched" Cartier-Bresson tradition, with a 35mm Leica.

But to photograph these subtle seascapes he switched to a bulky tripod-mounted view camera, which encouraged a more studied, contemplative approach appropriate to the moody poetry of these scenes. Compositions are kept simple, allowing the beauty of transient light and weather effects to work evocatively on the viewer. The distant figures and boats convey scale and suffuse the images with a sense of loneliness and human frailty.

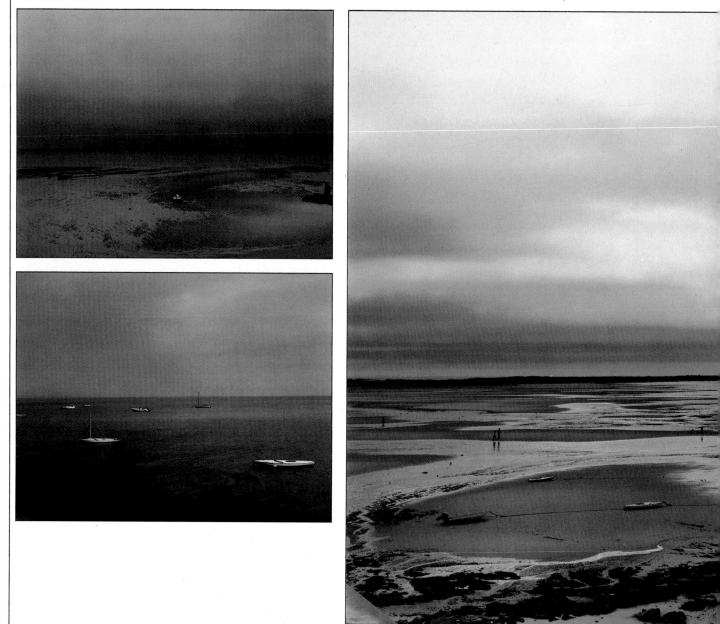

***The protean coast** of the Cape appears in five of its many moods, in a sequence of pictures taken from the same viewpoint at different times of day and under different tidal and weather conditions. The use of 8 × 10-inch sheet film with a slow speed of ISO 80, coupled with Meyerowitz's perfectionism in the darkroom, give the pictures their high degree of fidelity.*

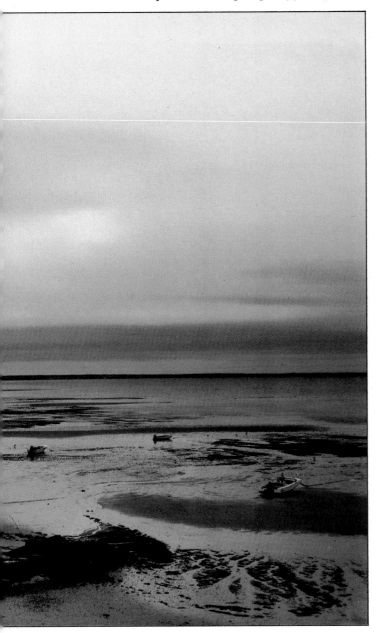

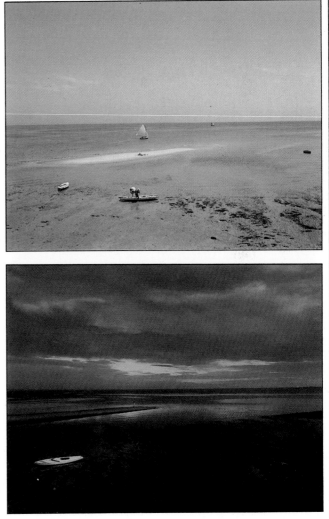

Waterscapes /1

Rivers, lakes and oceans make special kinds of landscapes: not static, like dry land, but ebbing and flowing, moving with the tides, winds and currents. And the forces that animate the landscape on solid ground have a double effect on water areas, because the reflective surface of the water echoes and distorts changing weather or the shifting color and position of the sun.

In the pictures on these and the following two pages, master photographer Ernst Haas focused on the many faces of water, from the reflective ripples of a placid fjord to storm-swept waves crashing on an exposed rock. Haas built on this simple theme by varying scale and viewpoint. For example, in the image on the opposite page, he closed in on just a few ripples near the camera, but for the large picture below he chose a much broader view.

As these images suggest, Haas's approach to his subject is straightforward and direct: he seldom uses a filter and never resorts to elaborate techniques or

photographic sleight of hand. When faced with a difficult theme or a recalcitrant subject, he relies on simplicity, honesty and his own genuine involvement with his subject to produce his images of quiet beauty. "For me it is important to forget myself when I photograph," Haas explains, ". . . to be totally loose, and react in a way that will surprise me, too." Complex camera equipment, he believes, is simply a burden and acts as a barrier between photographer and subject.

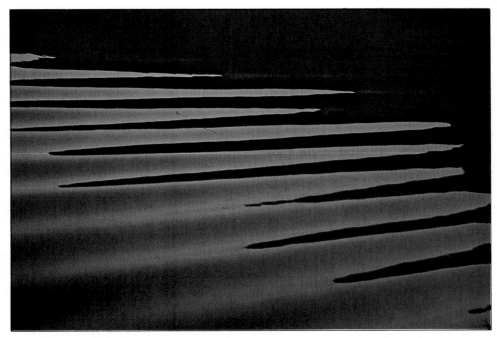

A water-soaked beach (left) reflects the warm light of a golden dawn. By setting a wide aperture and focusing on the opposite, shore, Haas softened the foreground, turning it to a formless area of rich color.

Gentle ripples disturb the calm of a fjord, creating a rhythmic pattern in shades of blue. A 200 mm lens enabled Haas, who was in a boat, to isolate the narrow band where the reflection of sky met that of land.

Waterscapes /2

The wake of a boat
glitters like scattered
diamonds when lit by
the late afternoon sun.
A small aperture and
a lens hood prevented
flare, which would have
cut down contrast and
spread the brilliant
highlights into the
picture's darker areas.

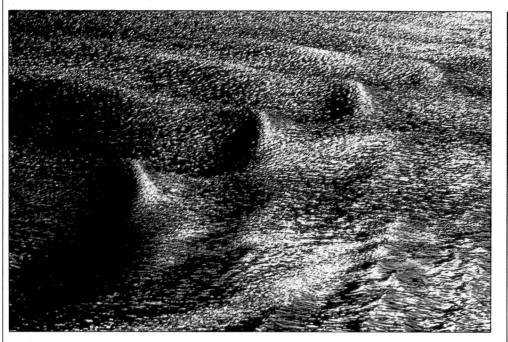

Crashing waves form soft, feather-like plumes during a 1/15 exposure. Haas pioneered the use of long exposures to suggest movement – partly from necessity, because the slow color film that he initially favored usually precluded the use of fast shutter speeds.

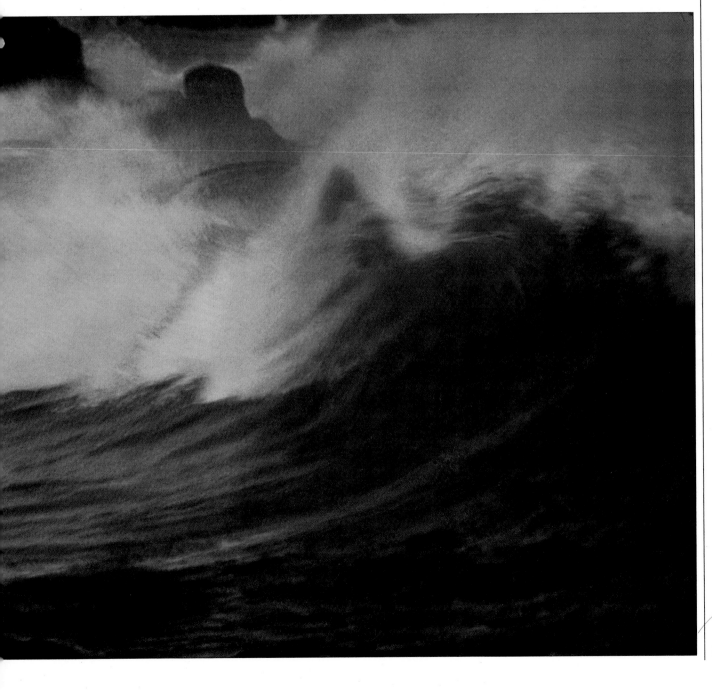

Water in harness

Elegantly curved dams, and the vast reservoirs they hold back, can make spectacular subjects for the camera, especially when they contrast dramatically with the surrounding natural landscape. The images here show different ways in which three American photographers have responded to this theme.

The curving shape of the dam and a sense of natural forces held in harness are important elements in all three images. But for the picture below,

Harald Sund pointed the camera straight down, turning the view into a pattern of converging lines. Larry Dale Gordon, who took the picture at right, abstracted the image in another way, by closing in on the tumultuous flow of water and excluding the surroundings to confuse the sense of scale. Barrie Rokeach chose yet another approach: in his image opposite, below, he contrasted the foaming water at the foot of the dam with the still pool above.

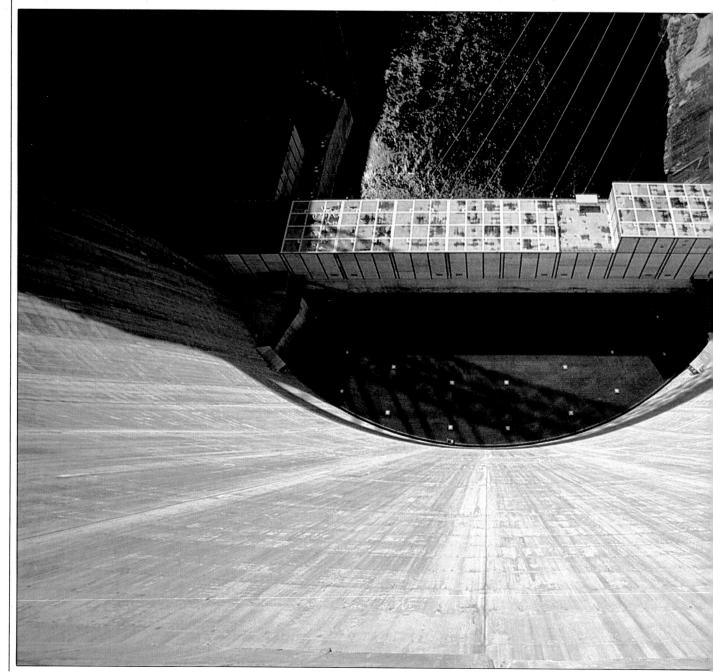

A turbine hall (below) at Arizona's Glen Canyon Dam forms the hub of this powerful composition. Harald Sund used a 24mm wide-angle lens so that the molding lines in the dam would converge more steeply, giving the viewer a sense of vertigo.

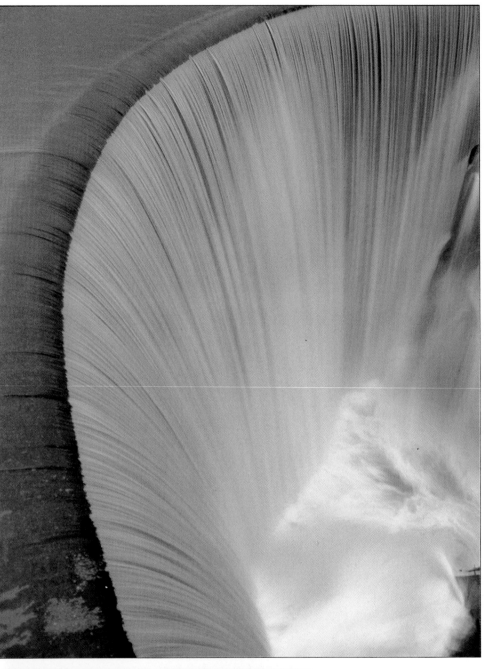

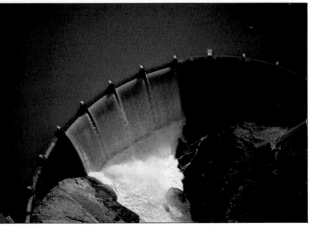

Like stretched silk, water falling from the rim of a dam in Tahiti (above) takes on the appearance of a fine white curtain at a shutter speed of 1/8.

An overflow dam (left) in California forms an emerald crescent above the frothing water that pours over its edge. Photographer Barrie Rokeach chose a high viewpoint to emphasize the reservoir's curved shape and used a polarizing filter to cut down reflections.

Sun and moon

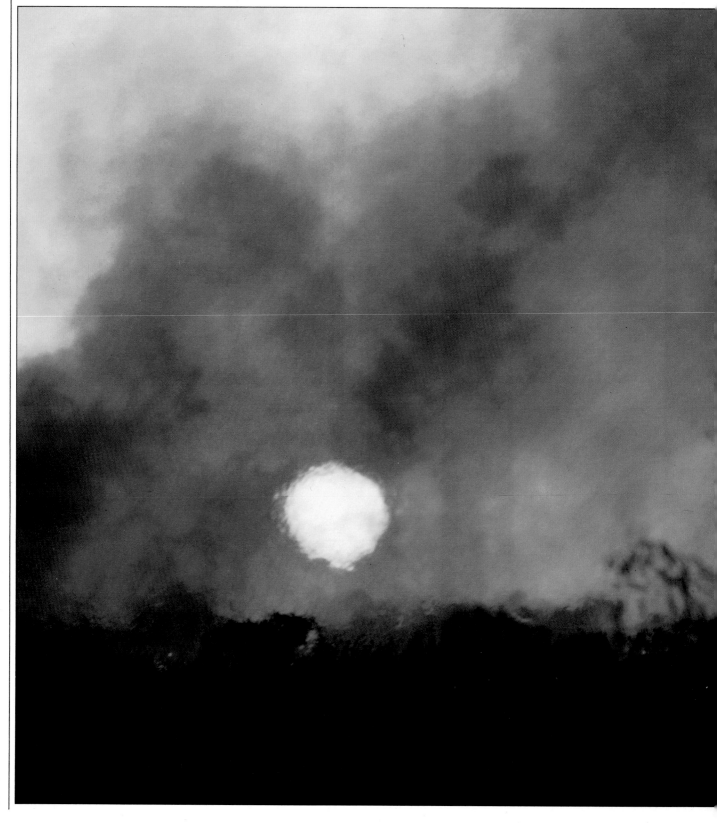

Spectacular as they may be, skies are rarely of sufficient interest to be landscape subjects in themselves. Some professional photographers overcome this problem by using the sun or moon as a compositional focus in a skyscape, providing a resting place for the viewer's eye. This is the approach taken in the pictures here: the globe or crescent of light gives compositional coherence to a view that is charged with turbulent energy.

If the sun or moon is to be the main element in a picture, it must be of reasonable size. Both photographers here used a telephoto lens to enlarge the subject. In the picture at left, Don Klumpp also made use of an optical illusion – the closer the sun is to the horizon, the larger it appears – and exploited the thick smoke of a forest fire to spread the light. The latter effect can also be achieved as successfully with atmospheric haze.

The moon requires a long exposure, especially when it is a crescent moon, which has a reduced reflective surface. For the picture below, photographer Alain Choisnet would not have been able to freeze the movement of the birds at the shutter speed setting required for the dim moon. He therefore took two consecutive pictures and combined them by sandwiching.

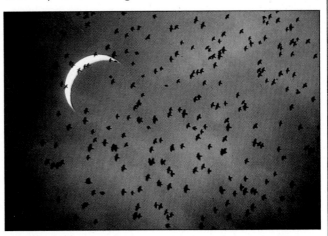

The brilliant disc (left) of the setting sun and black smoke from a fire combine in an image that evokes a feeling of fierce heat. The screen of smoke spread the color of the sun and made elements in the landscape seem to melt. Don Klumpp used a 300mm lens and deepened the red with a light orange filter normally used with black-and-white film.

A flock of birds (above) flies against the crescent moon. To obtain this unusual and striking image, Alain Choisnet sandwiched two transparencies together. For the birds picture, he took an average reading from an overcast sky and opened up by one stop. For the view of the moon, he set an exposure of 1/8, f/5.6.

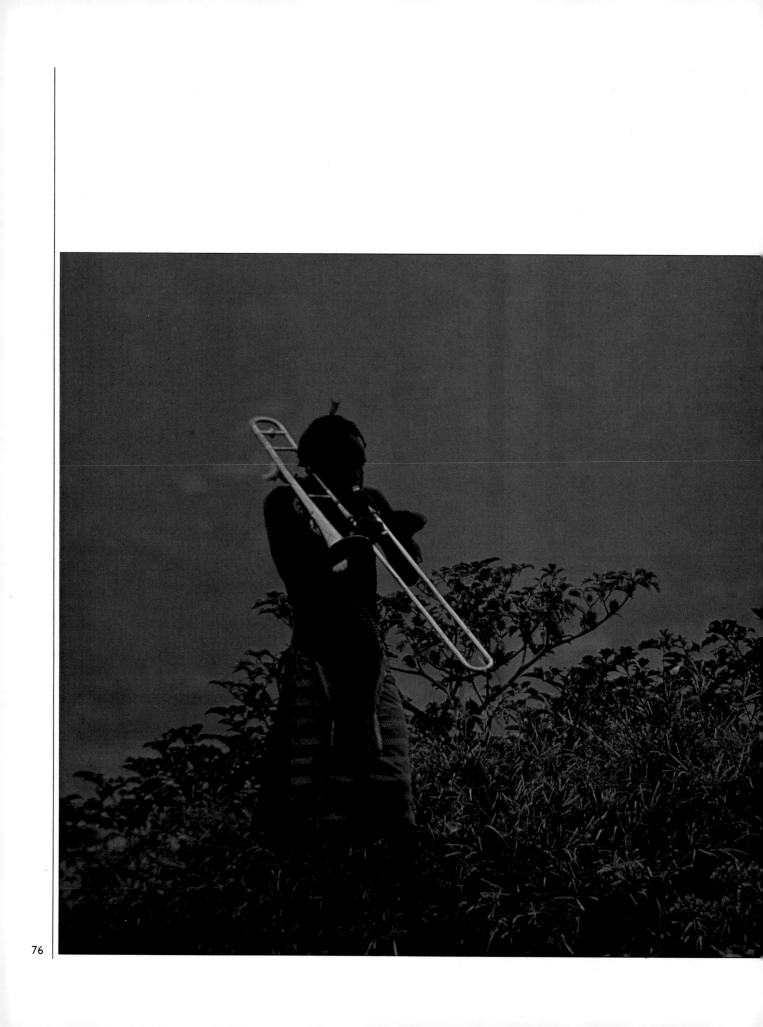

PERSONAL VISIONS

All photographers interpret what they commit to film; this is true even of the amateur who interprets a famous scenic view in a picture-postcard way. It takes imagination and insight to illuminate a subject's special visual, atmospheric or human connotations. And it takes something more – a strong creative personality – to develop, by experimentation and practice, a distinctive and steadfast way of seeing.

This concluding section examines the work of selected photographers whose images show a consistency of approach, whatever their assignment, or who have forged their own distinctive styles. Some favor a particular kind of viewpoint or composition, or are obsessed by variations on one theme. Others, such as Pete Turner, whose style is epitomized by the picture at left, use technical devices to mold reality to the shape of their own vision. Still others pare down the world to artful abstractions. All such approaches illustrate the wealth of creative choices that photography offers.

A silvery trombone, in the hands of a Swaziland tribesman, forms a strong focus of interest in an image by Pete Turner. Like much of Turner's work, this picture stands at several removes from reality. A blue filter simplified the colors. And to increase contrast and color saturation, Turner duped the original slide.

City details

Few photographers communicate as exuberant an enjoyment of colors, forms and textures, especially in the details of the urban environment, as Jay Maisel, who is based in New York's Bowery district. The three views here all convey his keen-eyed appreciation of the streets of Paris.

Many of Maisel's pictures rely heavily on the interplay of forms, colors and tones. He is particularly sensitive to lyrical lighting effects, especially the kind of late afternoon sunlight that gives a sensuous richness to the two pictures below. To judge exposure accurately, he prefers a handheld to a TTL meter, but he generally brackets.

One characteristic of Maisel's style of composition is his fondness for compressing planes by using medium or powerful long-focus lenses, whether to emphasize a two-dimensional pattern, as in the view at the bottom of this page, or to dramatize a contrast of textures, as in the picture below. Sometimes, too, he exploits selective focusing to isolate a detail – often just a partial detail – from the background, as in the graphic image opposite.

An ornate sculpture catches the sun and partially obscures a bus on a bridge. By minimizing depth with a powerful telephoto lens, Maisel offset the flamboyance of the sculpture against the clean lines of the bus.

Stacked chairs outside a café contrast in form, hue and texture with the blue canopy above. One of the elements in the scene that fascinated Maisel was the range of different tones in the chair backs. Using a 180mm lens, he framed the picture with unerring symmetry.

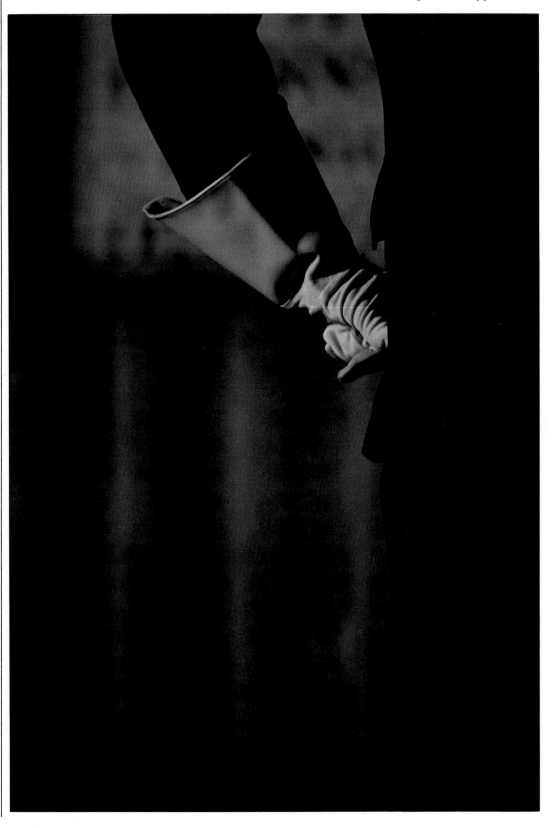

A policeman clenches his gloved hand against his hip, the raking sunlight revealing the glove's complex folds. A 400mm lens threw the background out of focus.

Seaside lights

Chris Steele-Perkins is a British photographer who often creates images that strongly evoke the atmosphere of a particular place or situation. The photographs here, commissioned for an exhibition on maritime England, show how color – specifically the color of artificial nighttime lighting – can establish this precise sense of mood.

Blackpool, the location of these pictures, is a popular seaside resort in northern England, well known for the illuminated displays along its seafront promenade and for its nightlife. Like many towns, especially tourist centers, it takes on a completely different character when darkness falls and the streets are full of a garish mixture of colors from different sources of artificial lighting. To convey the almost unreal exhilaration of it all, Steele-Perkins used ISO 64 daylight film and made long exposures that exaggerate the intensity of the night lights. Thus, the ballroom organist in the scene below at left is enveloped in a blaze of light. And in the picture of a life ring opposite, a tripod exposure made the ring and the railings stand out with unnatural clarity against the night sea as the exposure picked up and intensified the street lighting.

Ballroom dancers take the floor in the Grand Hall of Blackpool Tower. The photographer took the picture from a balcony, with his camera mounted on a tripod, and fired two bursts of flash during a one-second exposure at f/4. The dancing figures' movement caused ghosting.

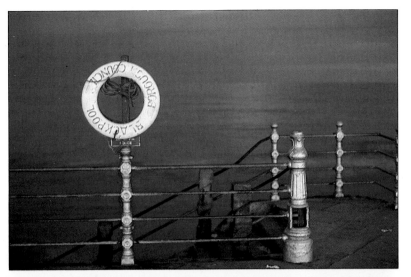

A life ring hanging on the promenade provides a crisp, distinctive shape and color contrast that holds the eye in a harmonious composition of soft, merging hues. The picture was taken in late evening with a half-second exposure, using the available light of the mercury vapor street lamps.

An illuminated tableau, also on the promenade, features a spacecraft and characters from the movie **Star Wars** *that stand out with a golden glow against the night sky. Steele-Perkins stood close and used a 35 mm wide-angle lens, exposing for one second at f/5.6.*

Hot-air balloons

Occasionally a photographer will hit upon a subject so inherently photogenic that it calls for a relatively reticent treatment that avoids sophisticated camera techniques. American photographer Vince Streano has discovered this quality in hot-air balloons.

Streano's pictures of balloons, which he often takes from other balloons, convey an unaffected pleasure in their shapes and colors. However, his approach is surprisingly versatile. In the image immediately below he allows the balloon to fill the frame in the type of composition that few photographers could resist. Yet, by contrast, in the other two views here he makes a well-judged use of background, allowing just enough space within the frame to suggest infinite sky in one picture, and unexpected solidity in the other.

A silhouetted figure reveals the scale of a hot-air balloon as it is being inflated. The photographer's viewpoint, looking into the balloon, emphasizes the symmetrical pattern, while floodlamps behind the balloon intensify its brilliant, glowing color.

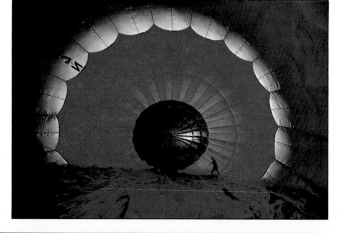

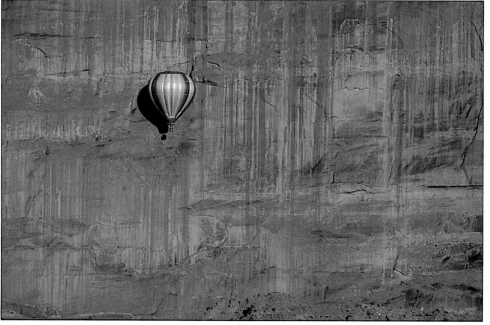

In Monument Valley, Arizona, a balloon floats against a sheer rock face. By closing in on the rock, Streano has created a claustrophobic feeling that is reinforced by the balloon's solid black shadow.

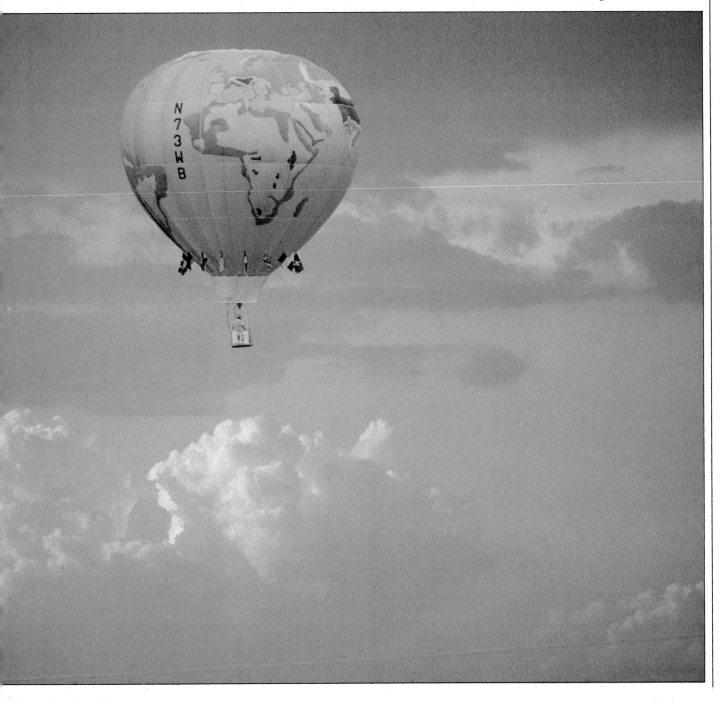

A map of the world decorates a balloon that floats in a pale blue sky flecked with clouds. Streano was attracted by the lyrical, simple symbolism in the subject – a make-believe world in blue space, such as a child might draw.

Night trains /1

Photographers frequently specialize in a single subject or theme. But few do so with the single-mindedness of O. Winston Link, who took the pictures here and on the following two pages between 1955 and 1960. When he saw a news headline announcing the phased withdrawal of steam trains from the Norfolk and Western Railroad in Virginia, he became absorbed with the idea of documenting the power and majesty of the steam locomotive before it disappeared from service.

If they were straightforward portraits of trains, Link's images would be of interest only to steam enthusiasts. However, the pictures are much more than that. In some, the train plays a supporting role, and the spotlight is on action in the foreground of the picture, as in the gas station scene below at left. In others, one has to look quite hard even to see the locomotive.

Besides the railroad theme, Link's pictures share another characteristic: almost all were taken by flash. He used the darkness of night to create a seamless black backdrop, allowing him to light the train and surroundings exactly as he chose. Electronic flash would have been too weak to illuminate this vast

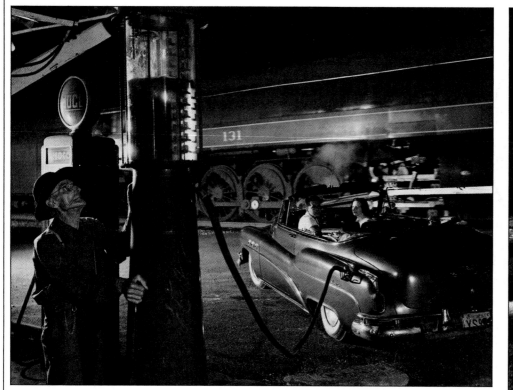

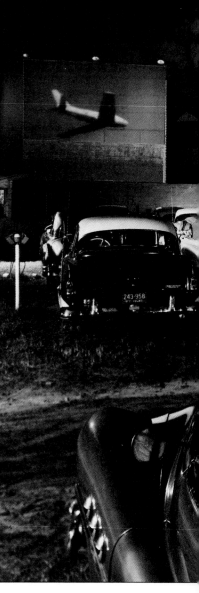

Stopping for gas in Vesuvius, Virginia, a young couple ignore the passenger train hurtling past behind them in a carefully staged photograph taken by Link in 1956. For this and all his pictures, he used a 4 × 5-inch view camera.

outdoor studio, so Link used large magnesium-filled flashbulbs instead – he needed 43 for the large picture below. Since these were not reusable, there was rarely a second chance to photograph each scene; to reduce the risk of failure, Link used several cameras, synchronizing their shutters electrically.

Link's pictures demonstrate the creative rewards of concentrating on a single theme over a period of time. Although each picture is of documentary and esthetic interest in its own right, together they form a remarkable photographic record, unified by a consistency of both subject matter and technique.

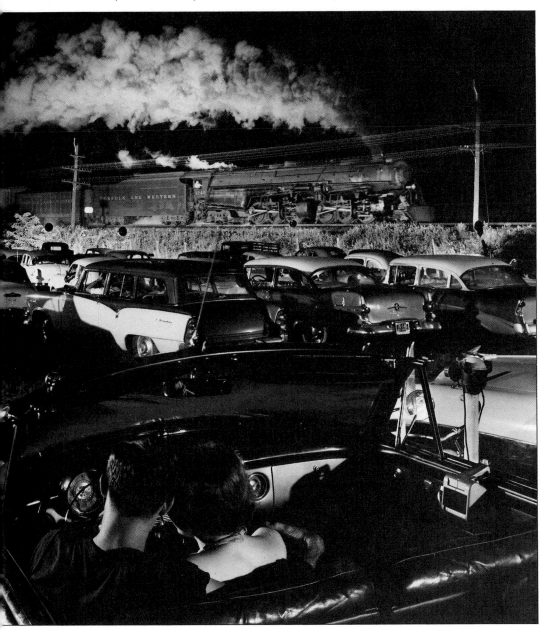

A drive-in movie frames a Class A 1200 series locomotive. Until the flash fired, Link could see only the headlight of the train. He pressed the shutter release when the headlight was midway between two carefully positioned lamps that marked the frame edges.

Night trains/2

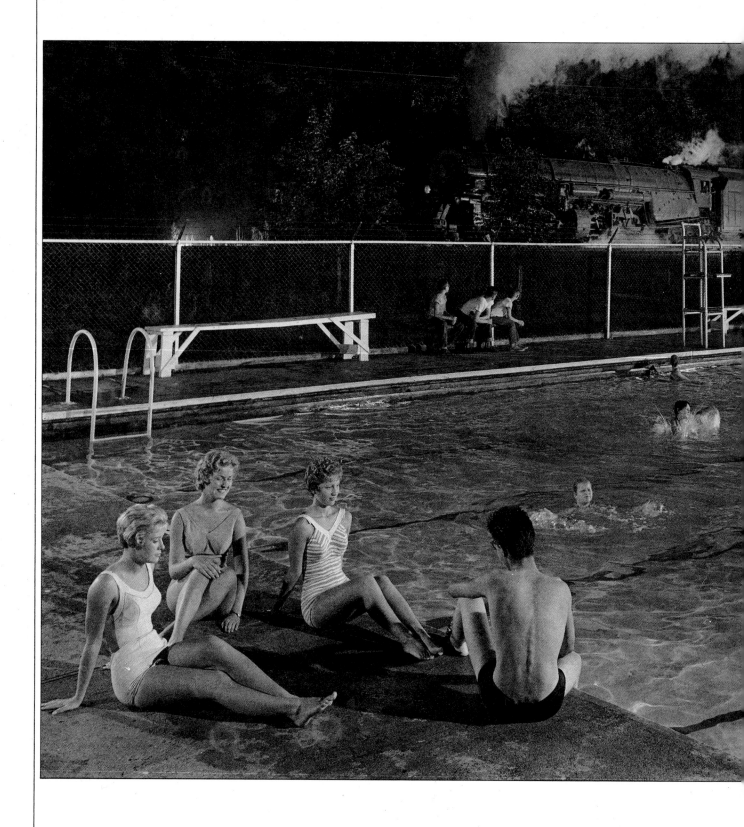

A poolside group (left) and a passing locomotive are lit brilliantly by O. Winston Link's eight powerful banks of flashlamps. To fire all the bulbs simultaneously, he ran 1½ miles of cable around the edge of the pool.

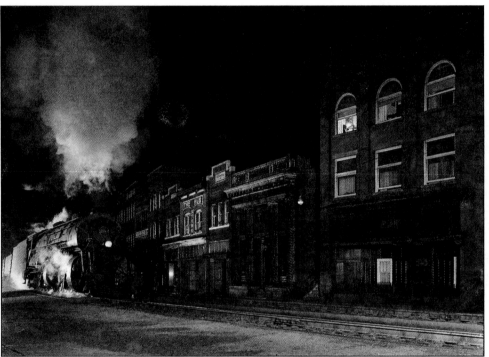

A freight train breathing smoke (above) divides the main street of Norfolk, Virginia. Link posed a nonchalant figure at a high window to illustrate how thoroughly the railroad was integrated into town life.

The wheels of a train (left) rattle past just outside the window of a Virginia home – closer, in fact, than this wide-angle view suggests. To avoid reflections, Link took special care in positioning his flash lamps.

Saturated color

Dreams and fantasies often occur in vivid, brilliant colors that the real world – and photographs of it – never quite seem to match: except, that is, in the work of New York photographer Pete Turner. His images have an improbable richness of color, a saturation that sometimes defies belief. For example, the bus in the picture below looks more like a super-realist painting than a color photograph.

The rich colors in Pete Turner's pictures are no accident. He refined his mastery of color film through thirty years of practice and experiment, and he now has a methodical and, in principle, quite simple way of committing to film the images that his fertile imagination conjures up. He uses slow color transparency film – Kodachrome 25 – because it produces the highest color saturation of all films. He

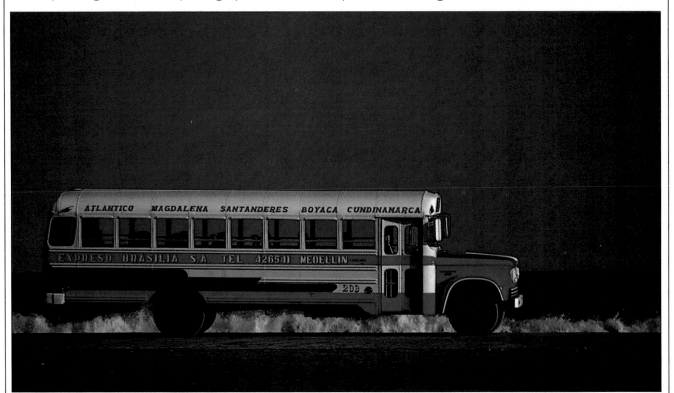

A sunlit bus (above), parked on the seashore at Cartagena, Colombia, glows with color against the dusk sky. By using a polarizing filter, Turner both darkened the sky and reduced the reflections from the bus's shining paintwork.

Whorls of paint (right) create a vibrant pattern that recalls old marbled paper. Floating the oil-based paint on water in his studio, Turner was able to control the intermingling of the colors precisely.

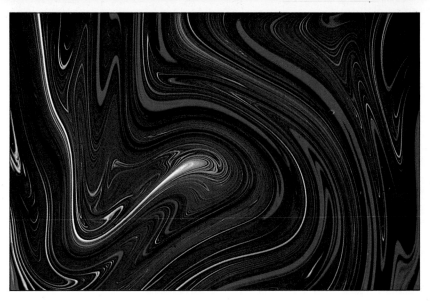

increases the richness of the colors still further by underexposing. And, after processing the film normally, Turner enhances the hues by copying the pictures onto the same type of slow color film. This causes an increase in color saturation and contrast that is normally regarded as an undesirable side-effect of transparency duplicating, but that Turner uses as a personal hallmark.

The duplicating stage not only makes hues brighter, but also provides the opportunity to combine several images in one composition. Masking off unnecessary parts of each frame, Turner sometimes combines up to five or six separate transparencies by sandwiching or double exposure. The image below is a simple example that demonstrates the potential of this multiple-image technique.

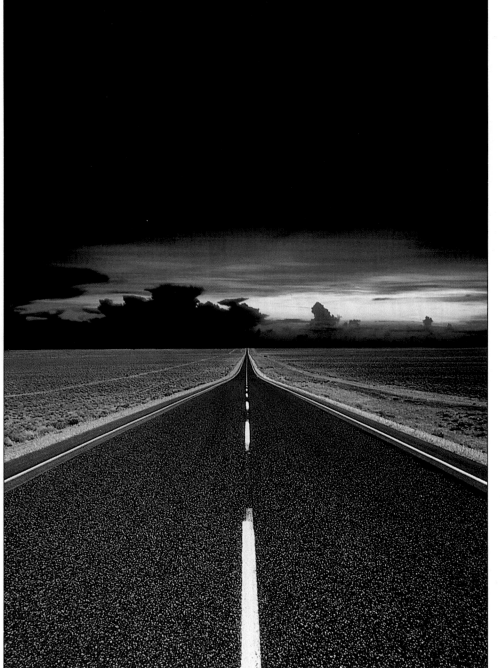

An endless highway stretches out toward the last rays of a sun that is actually from a different landscape. A slide duplicator brought together the two images – sky and road – from two separate color transparencies.

Color and shape

Carrying around a camera, a tripod, several lenses and a selection of accessories extends versatility, though at some cost in convenience. One photographer willing to make such a sacrifice is Al Satterwhite, who often travels with a range of lenses, from a fisheye to a 300mm, as well as several camera bodies, at least one tripod and a set of filters. Being so well outfitted produces an enormous gain in creative freedom and the power to experiment. Satterwhite manages to take advantage of this freedom and yet produces images that have a highly individual feel to them. The key to his unique style is his handling of color, combined with the interplay of shapes in striking compositions.

Satterwhite prefers bold colors. Often he will arrange a picture around just two areas of primary color; this is as true of the photograph on the opposite page at top, which offsets red taillights against a blue sky, as it is of the more obvious juxtaposition of red and yellow in the picture below it.

Similarly, Satterwhite takes an assertive approach to composition by placing graphic shapes in a delicate balance. For example, for the large picture here, he used an extreme wide-angle lens that brought the traffic signs and the band of ocean into a finely judged relationship that has a sense of precarious counterpoise typical of his work. Equally characteristic of Satterwhite's style is the use of signs to introduce angular shapes and bright, even colors into an image.

A swirl of red tubes suggests the passage of a car through a western landscape at twilight. To create this dynamic composition, Satterwhite made two exposures on one frame. First he photographed the landscape under a full moon; then, he recorded a car's taillights as a streak of light by leaving the shutter on its B setting for 10 seconds. The cactus silhouette links the two halves of the image.

A bent warning sign (left) leans into an ocean view, producing a graphic effect. Satterwhite used a 20mm lens and a polarizing filter that darkened part of the sky, adding a patch of saturated blue that strengthens the composition.

A pedestrian (above) in front of a red wall seems to defy the command of a huge yellow arrow. By duplicating the original slide in a copier, Satterwhite increased both the contrast and the color saturation of the image.

Light as energy

An actor's face (*left*) is dissolved in the light around his dressing room mirror, although the reflection itself remains intact. Griffin deliberately overexposed the brightly lit face to burn out the features, thereby expressing the idea that an actor's profession involves the suppression of his own personality.

The best photographic fantasies are often achieved with a minimum of technical trickery. More important are a restless imagination and an exact knowledge of how the subject will appear on film. This kind of imaginative confidence is a hallmark of the young English photographer Brian Griffin, whose style is exemplified on these two pages. His arresting special effects are deceptively simple: for example, the center picture here looks like a darkroom manipulation, but in fact was captured on one frame with the help of a flashgun and a skyrocket. Careful work in the darkroom enhances this photographer's images, but their main impact is achieved at the moment of pressing the shutter release.

Light is Griffin's chief preoccupation. "Light," he has said, "is energy. Light is life." His interest in spectacular lighting effects dates back to his childhood in England's industrial heartland, where at night he could see the theatrical glow of a steelworks from his bedroom. In many of his photographs, such as the portrait above, light is used for powerful symbolism as well as for its visual appeal.

A man transfixed by light confronts the ocean (*right*). For this effect, the subject set off a skyrocket just in front of him and then fired a flash attached to the front of his trousers while the photographer held the shutter open. Griffin intended the vivid image to evoke nuclear power and the threat of a nuclear accident.

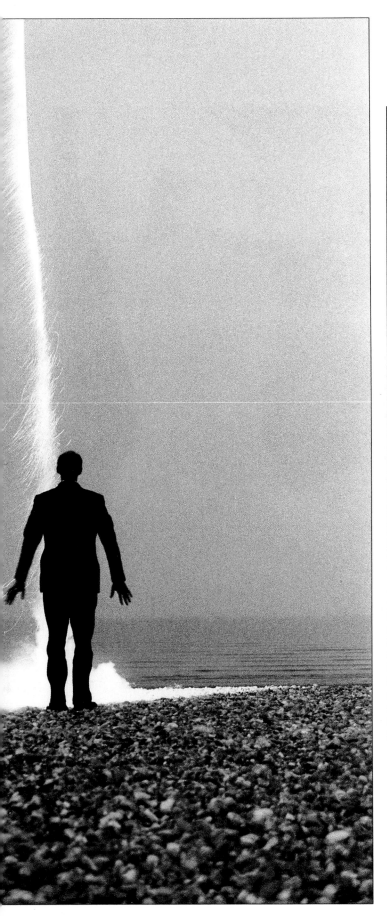

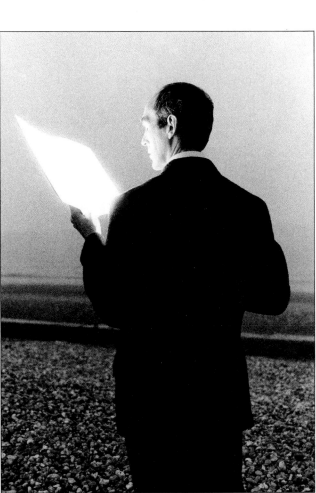

A man in a dark suit
(above) lifts a mysteriously luminous booklet to his closed eyes, against a background of pebbles and waves. Like the picture at left, this image depends for its effect on a carefully angled flashgun in front of the man. Reflected light off the white paper gave an eerie glow to the face.

Surreal nudes

In his long and illustrious career, which began in the 1920s, British photographer Bill Brandt tackled a wealth of themes, from portraiture to documentary studies of London life during the Blitz. This impressive range of subject matter reflects the breadth and versatility of a tireless, generous intelligence. And each of his pictures exhibits a highly personal style that gives unity to his work.

These nude studies from the 1950s exemplify the quality that Brandt called "atmosphere . . . the spell that charges the commonplace with beauty." This is partly the result of offbeat composition. But the atmosphere was strengthened by work in the darkroom. Brandt printed on high-contrast paper to blacken the shadows, give a weird luminosity to the highlights and increase grain. The surreal style that this technique reinforces is influenced by the work of the American painter and photographer Man Ray, with whom Brandt worked in Paris.

When he photographed these nudes, Brandt was experimenting with the foreshortening effect of an old shutterless 8 × 6-inch Kodak camera with an extreme wide-angle lens and pinhole aperture. The unsettling distortions, most noticeable in the picture at near right, create almost abstract effects and are a crucial component of the intensity of mood he attempted to evoke.

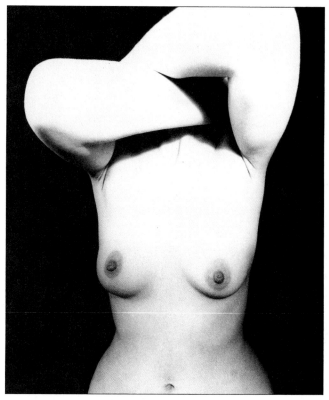

Folded arms (above), exaggerated by his camera's wide-angle lens, mask the face of Brandt's model to create an image with a strange sensuous beauty, despite the unnatural proportions. Because of the high-contrast printing paper, the nude almost seems sculpted from light itself.

A pebbly beach (left) contrasts with the skin textures of a partial nude in close-up. The wide-angle lens gives the picture its extraordinary depth. The haunting quality of the image owes something to the puzzle of the pose and to the ancient association of womanhood with the sea's fertility.

An extreme close-up turns a nude
into an unearthly landscape. The
novelist Lawrence Durrell referred to
Brandt's approach in such powerful
images as a "prolonged meditation on
the mystery of forms."

Pale nudes

The studio nude is among the most challenging of all photographic subjects. It is difficult to achieve a pose that does not look too stilted, or a lighting arrangement that puts shadows exactly where they are wanted. For some photographers the total control that the studio confers can have an inhibiting effect on the imagination. Furthermore, any photographer familiar with the work of others who have explored this classic theme may find it impossible to avoid taking pictures that are unconsciously derivative.

Tokyo-based photographer Hideki Fujii has successfully overcome such obstacles to create a distinc-

tive idiom of his own. His highly stylized images, exemplified on these pages, bear the unmistakable mark of their maker. Characteristically, he avoids natural skin tones and instead seeks an effect of pallor through lighting and exposure techniques, either alone or in combination with white body paint. For stark contrasts, his backgrounds are often plain black, though he will sometimes take the opposite approach of posing a white or pale figure against a white background, so that the two almost blend, as in the effective image below at left. The formal or contorted poses of Fujii's models, and the

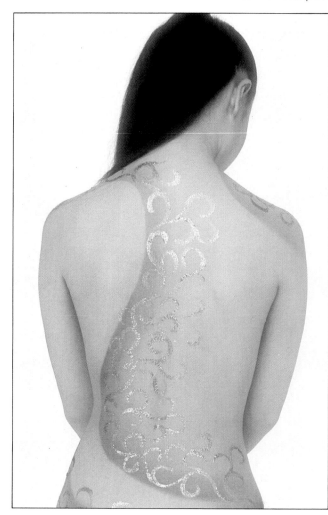

Swirling brushstrokes of red and gold suggest movement on a nude's painted back, producing an effective contrast with the motionless symmetry of the pose. The absence of shadows, caused by soft, multiple lighting and well-placed reflectors, creates a mood of extreme artifice.

dramatic patterns often painted on their skin, have overtones of ritual. Distinctive eye makeup often enhances an Oriental flavor.

Although they celebrate the suppleness of the human body, Fujii's nudes have an air of subjection about them. This quality derives from his absolute control of every aspect of his images. Even the laws of gravity or of light are seldom allowed their rival claims: in neither picture here is the hair allowed to fall naturally, and in both images shadows are eliminated almost entirely by using multiple diffused lighting and judiciously placed reflectors.

A reclining nude in a contorted pose seems to glow with a strange luminescence against a dense black background. To achieve the soft outline, Fujii used a filter smeared with gel. He deliberately overlit the subject to lose definition in the model's features.

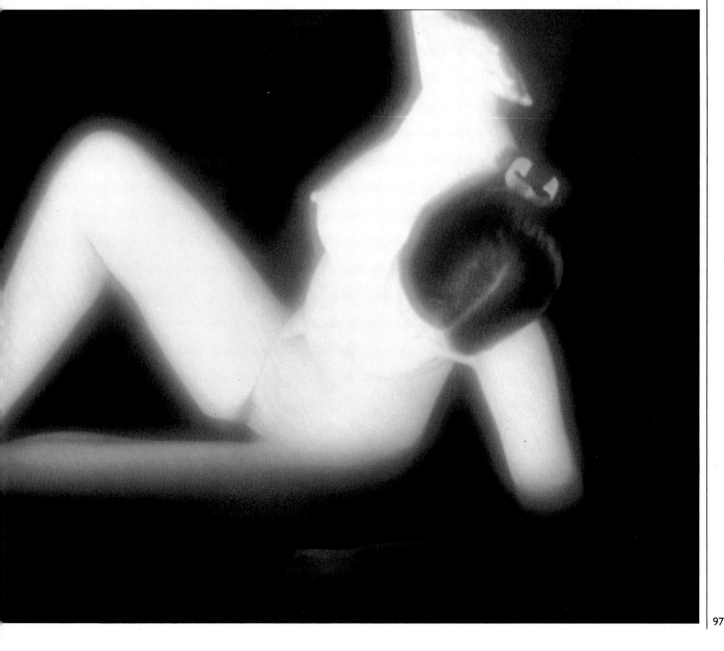

Grace and movement

The combination of strength and gracefulness that characterizes ballet can be difficult to express in a photograph. A picture that freezes a single leap may miss the continuity and rhythm in dance, while a delicate, soft-focus approach may suggest airy grace but not the tense energy of the dancer's body.

John Starr uses a wide variety of techniques to capture the special character of ballet. His experience as a sports photographer enables him to anticipate instinctively a moment to record that sums up the mood and style of a performance. Long exposures, often combined with camera movement, emphasize the shape and tempo of choreography. Even though, in the pictures here, a slow shutter has blurred most of the subject, small areas of relative sharpness give definition. The blurring helps to remove any sense of personality from the figures – it is the abstract shapes that are important. To emphasize movements, Starr takes advantage of the harsh contrast of stage lighting: he looks for deeply shadowed areas of the stage, where the spotlit figures stand out most strongly, and he always keeps backgrounds as plain and undefined as possible, as the pictures here illustrate.

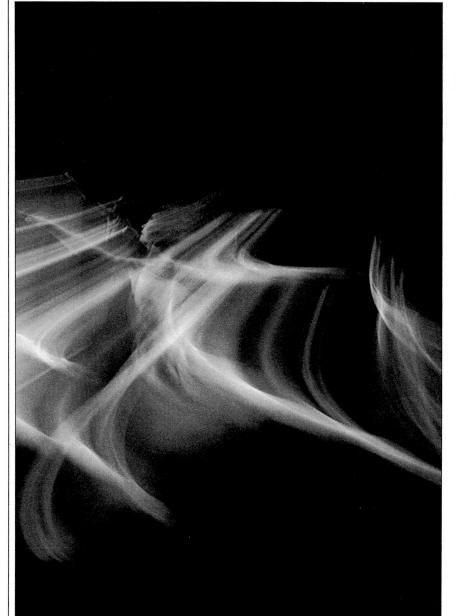

A turning movement (above) is expressed in a simple abstract shape. Setting the shutter at 1/30, Starr moved his camera in the direction of the turn. The sparkly costume, colored spotlights and a textured screen in front of the lens produced the bright, grainy image.

A series of leaps across the stage (left) are rendered in arcs of light. A setting of 1/15 at f/5.6 slightly overexposed the figures, accentuating their fluid shapes against the blackness. The photographer followed the dancers with the camera to emphasize rhythm and dynamic energy.

A ballerina's poise and strength are revealed in the graceful curve of her body (right). Unlike the other images here, this is a carefully composed studio picture: the photographer used two lamps, one behind and one to the side of the subject, and a smoke machine for a soft, diffused effect.

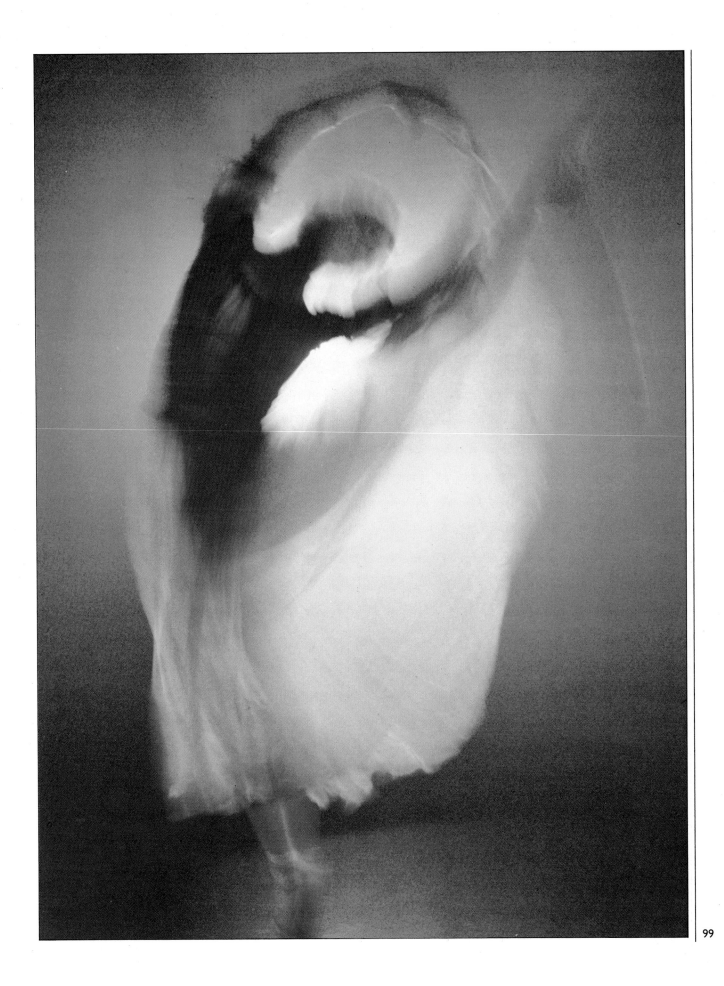

Substance and shadow

John de Visser is best-known for his Canadian life and landscape scenes, but he is also fascinated by many other subjects. One idea that has intrigued him is the borderline between the abstract and the representational in photography, as in these richly ambiguous studies showing the interplay of substance and shadow.

Like silhouettes, shadows reduce complex objects to simplified flat shapes. Depending on the intensity of the sun, they may be black and hard-edged or pale and soft, taking on the character of the surface they are cast on; and depending on the angle of the surface and the height of the sun, they may be compressed or elongated. In addition to this variety, de Visser recognizes the potential of shadows for creating illusion. In the large picture here, the simple ele-

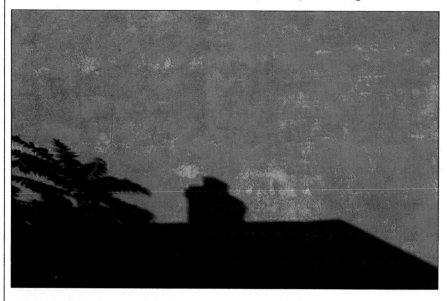

A housetop and tree (above) appear in shadow on a large wall. The photographer noticed the resemblance of the peeling paint to cottony clouds in a blue sky, and framed the shadow to create a witty image. The exposure was taken from the sunlit area to retain detail.

A plant (below) on a window ledge, between a net curtain and an orange blind, makes an intriguing study. The soft-edged shadow of a tree trunk outside the window, and the white-painted woodwork at the edge of the frame, help balance the composition.

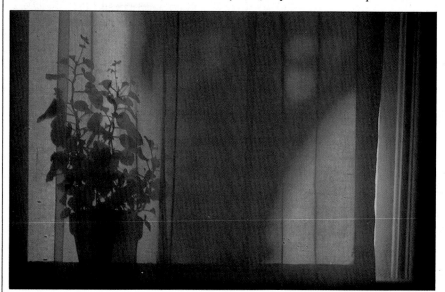

ments are composed in such a way that light seems to bend around a corner to throw a shadow of a tree on a wall. The picture of shadows opposite at top creates a playful illusion of silhouette and sky. And in the image below it, an unusual treatment of the classic theme of a windowsill still-life raises doubts about what exactly we are seeing, and whether the plant is silhouette or shadow.

Palm frond shadows (below) give atmosphere to a Jamaica seascape in a photograph taken shortly after sunrise. Using a wide-angle lens, de Visser chose his viewpoint to create an image divided dramatically in two by the strong line of the wall. The foreground shadows repeat the pattern of the palm leaves, providing a link between the two distinct areas.

Glossary

Available light
The existing light (natural or artificial) in any situation, without the introduction of supplementary light (for example, flash) by the photographer. The term usually refers to low light levels, such as those indoors or at dusk.

Backlighting
A form of lighting where the principal light source shines toward the camera and lights the subject from behind.

Bracketing
A way to ensure accurate exposure by taking several pictures of the same subject at slightly different exposure settings above and below (that is, bracketing) the presumed correct setting.

Burning out
Loss of detail in the highlights of an image, due to overexposure.

Cast
An overall tinge of a particular color in a print or transparency. Color casts often occur when the light source illuminating the subject of a photograph is not matched to the film.

Copier see SLIDE COPIER

Cropping
Trimming an image along one or more of its edges to eliminate unnecessary parts, or framing a scene to leave out parts of the subject.

Daylight film
Film balanced to give accurate colors when exposed to a subject lit by daylight or light of similar color temperature – for example, electronic flash.

Depth of field
The zone of acceptably sharp focus in a picture, extending in front of and behind the plane of the subject most precisely focused by the lens.

Duplicator see SLIDE COPIER

Film speed
A film's sensitivity to light, rated numerically so that it can be matched to the camera's exposure controls. The two most commonly used scales, ASA (American Standards Association) and DIN (Deutsche Industrie Norm), are now superseded by the system known as ISO (International Standards Organization). ASA 100 (21° DIN) is expressed as ISO 100/21° or simply ISO 100.

Graduated filter
A filter with a clear and a colored half that gradually blend into each other. A graduated filter can be used to enliven a dull sky in a landscape, for example, without affecting the rest of the image.

Grain
The granular texture appearing to some degree in all processed photographic materials. In black-and-white photographs the grains are minute particles of black metallic silver that constitute the dark areas of a photograph. In color photographs the silver is removed chemically, but tiny blotches of dye retain the appearance of the grain. The more sensitive – or fast – the film, the coarser the grain will be.

Highlights
Bright parts of a subject that appear as the darkest areas of a negative or as the lightest areas in a print or transparency.

ISO see FILM SPEED

Large-format camera see VIEW CAMERA

Long-focus lens
A lens that includes a narrow view of the subject in the picture frame, making distant objects appear closer and magnified. Most long-focus lenses are of the type known as telephoto lenses. These have an optical construction that results in their being physically shorter than their focal length, and thus easier to handle than non-telephoto long-focus lenses. In fact, almost all long-focus lenses are now telephoto lenses, and the two terms tend to be used interchangeably.

Midtones
Gray tones midway between highlights and shadows.

Panning
A technique of moving the camera to follow the motion of a subject, used to convey the impression of speed or to freeze a moving subject at slower shutter speeds. Often, a relatively slow shutter speed is used to blur the background while panning keeps the moving object sharp. This technique is particularly useful in sports photography.

Polarizing filter
A filter that changes the vibration pattern of light passing through it, used chiefly to remove unwanted reflections from an image or to darken the blue of the sky.

Primary colors
Blue, green and red – the colors of light that when mixed together equally make white light and that when mixed in various combinations can make any other color. Saturated colors are "pure" colors that reflect only one or two primaries; when a third primary is introduced the color is "desaturated" toward white, gray or black.

Reflector
Any surface capable of reflecting light; in photography, generally understood to mean sheets of white or silvered cardboard that are used to reflect light into shadow areas.

Sandwiching
Combining two or more negatives or slides to produce a composite image either on one sheet of printing paper or on a slide-projecting screen.

Saturated colors see PRIMARY COLORS

Shadows
Dark parts of a subject that appear as the lightest areas of a negative or as the darkest areas in a print or slide.

Skylight filter
A pale filter that helps cut down the amount of blue light entering the camera. Some photographers keep skylight filters permanently in place over lenses to protect them from damage.

Slide copier (duplicator)
A device incorporating a lens, a camera mount and a slide holder, used to make duplicates of transparencies.

Soft focus
Deliberately diffused or blurred definition of an image, often used to create a dreamy, romantic look in portraiture. Soft-focus effects are usually achieved with special screens or filters.

Telephoto lens see LONG-FOCUS LENS

TTL
An abbreviation for "through-the-lens," generally used to refer to exposure metering systems that read the intensity of light that has passed through the camera lens.

Tungsten light
A very common type of electric light for both domestic and photographic purposes – named after the filament of the metal tungsten through which the current passes. Tungsten light is much warmer (more orange) than daylight or electronic flash, and you must use a filter with daylight-balanced color film to compensate for this if you want to reproduce colors accurately. Alternatively, use tungsten-balanced slide film.

View camera (large-format camera)
Camera that produces a large image on sheet film – a negative or transparency 4 × 5 inches or larger. An inverted image is focused on a ground-glass screen at the back of the camera. A flexible bellows links the lens panel with the film holder.

Index

Acknowledgments

Picture Credits

Abbreviations used are: t top; c center; b bottom; l left; r right. Other abbreviations: IB for Image Bank. All Magnum pictures are from the John Hillelson Agency.

Cover Bruce Davidson/Magnum

Title Georg Gerster/John Hillelson Agency. **7** Burt Glinn/Magnum. **8** Burk Uzzle/Magnum. **9** Michelle Garrett. **10-11** Philip Jones-Griffiths/ Magnum. **11** Chris Steele-Perkins/Magnum. **12** Adam Woolfitt/Susan Griggs Agency. **13** Harald Sund/IB. **14** Vautier/de Nanxe. **14-15** René Burri/Magnum. **16-17** Paul Fusco/Magnum. **18** Laurie Lewis. **18-19** Robin Laurance. **19** Laurie Lewis. **20-21** all Vautier/de Nanxe. **22-23** all Henri Cartier-Bresson/Magnum. **24-25** all Ken Griffiths. **26-27** all Jane Bown/ Observer. **28-29** all Bruno Barbey/Magnum. **30-31** all Tim Page. **32** t Elliott Erwitt/Magnum, b Burt Glinn/Magnum. **32-33** Thomas Höpker/ Magnum. **33** Francisco Hidalgo/IB. **34-35** all Harry Gruyaert/Magnum. **36** t Burt Glinn/Magnum, b Jean Gaumy/Magnum. **36-37** Paul Fusco/ Magnum. **38** t Vautier/de Nanxe, b John de Visser. **38-39** Philip Jones-Griffiths/Magnum. **40** Thomas Höpker/Magnum. **40-41** Ernst Haas/ Magnum. **41** Alex Webb/Magnum. **42-43** all Eamonn McCabe. **44-45** Dennis Stock/Magnum. **46-47** Ken Griffiths. **47** t John Freeman, b John de Visser. **48** Bruno Barbey/Magnum. **48-49** Harry Gruyaert/Magnum. **49** Ernst Haas/Magnum. **50-51** all David Muench/IB. **52-53** Ernst Haas/ Magnum. **53** Pete Turner/IB. **54-55** all Thomas Höpker/Magnum. **56-57** Dennis Stock/Magnum. **57** Ernst Haas/Magnum. **58-59** all Franco Fontana/IB. **60** Dennis Stock/Magnum. **60-61** Vautier/de Nanxe. **61** René Burri/Magnum. **62** Ernst Haas/Magnum. **62-63** Ernst Haas/Magnum. **63** René Burri/Magnum. **64-65** Erich Lessing/Magnum. **65** t Bullaty/ Lomeo/IB, b Dennis Stock/Magnum. **66-67** all Joel Meyerowitz/IB. **68-69** all Ernst Haas/Magnum. **70-71** all Ernst Haas/Magnum. **72-73** Harald Sund/IB. **73** t Larry Dale Gordon/IB, b Barrie Rokeach/IB. **74-75** Don Klumpp/IB. **75** Alain Choisnet/IB. **76-77** Pete Turner/IB. **78-79** all Jay Maisel. **80-81** all Chris Steele-Perkins/Magnum. **82-83** all Vince Streano/ Click/Chicago. **84-85** all O. Winston Link. **86-87** all O. Winston Link. **88-89** all Pete Turner/IB. **90-91** all Al Satterwhite/IB. **92-93** all Brian Griffin. **94-95** all Bill Brandt. **96-97** all Hideki Fujii/IB. **98-99** all John Starr. **100-101** all John de Visser.

Kodak, Ektachrome, Kodachrome and Kodacolor are trademarks

Time-Life Books Inc. offers a wide range of fine recordings, including a *Big Bands* series. For subscription information, call 1-800-621-7026, or write TIME-LIFE MUSIC, Time & Life Building, Chicago, Illinois 60611.

Notice: all readers should note that any production process mentioned in this publication, particularly involving chemicals and chemical processes, should be carried out strictly in accordance to the manufacturer's instructions.